IMAGES
of America

RENSSELAER

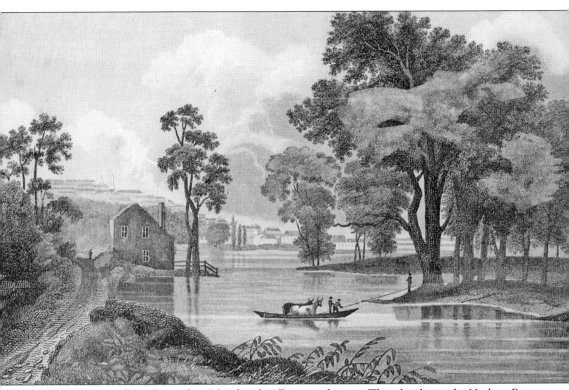

This is a view of Van Rensselaer Island with Albany in the rear. The island is in the Hudson River next to the shore of Rensselaer. This island no longer exists because the channel separating it from the shore was filled in 1903. It was the location of the Rensselaer Junior Senior High School. It was also known as Boston or Boston & Albany Island because of the Boston & Albany railroad shops on the northern end of the island, and was also called Bonacker Island, after an icehouse and baseball/boxing field once located on the island. In the 17th century, it was known as De Laet's Island and was the site of a Native American house. This engraving was made in 1830 after a painting by William Guy Wall. (Courtesy of the Rensselaer City History Research Center.)

ON THE COVER: The cover photograph is of a parade through the city of Rensselaer in 1917. Marching in front is the E.F. Hart Hose Fire Company. (Courtesy of the Rensselaer City History Research Center.)

IMAGES
of America

RENSSELAER

Charles Semowich, PhD

ARCADIA
PUBLISHING

Published by Arcadia Publishing
Charleston, South Carolina

Printed in the United States of America

Library of Congress Control Number: 2011942237

For all general information, please contact Arcadia Publishing:
Telephone 843-853-2070
Fax 843-853-0044
E-mail sales@arcadiapublishing.com
For customer service and orders:
Toll-Free 1-888-313-2665

Visit us on the Internet at www.arcadiapublishing.com

Dedicated to Mayor Daniel J. Dwyer, whose vision has moved the city forward. His commitment to our history is outstanding. Also dedicated to Barbara Milano, Judy Schmidt, Josephine Conway, Richard Semowich, Wendy Wilson, Stephen Betts, and Wallace Carter Schmidt.

CONTENTS

ACKNOWLEDGMENTS

There are many people and institutions that have assisted me with this project and to whom I must provide the most grateful thanks. Special appreciation must be given to Ernie Mann for both reviewing and commenting on the text and the generous loan of some of these great photographs. Raymond Hull, Kathryn Sheehan, and Shirley Dunn were very gracious to review the introduction and made many useful comments. Others who have helped and whose assistance were invaluable are Sharon Zankel, Cathy Ody, Beth Bornick, Warren Broderick, Crailo State Historic Site, Heidi Hill, Mayor Daniel J. Dwyer, Maureen Nardacci, the City of Rensselaer Historical Society, Joe Connors, Kathryn Sheehan, Jack Schumaker, Rita Buchanan, the Troy Public Library, the Rensselaer County Historical Society, the Albany Institute of History and Art, the New York State Library, Waldi Cavanaugh, Rick Leissring of the Glenn H. Curtiss Museum, William Flanigan, the Rensselaer City Common Council (Harry Adalian, Marion Webber, James Van Vorst, Phil Elacqua, Gretchen Poole, Dominick Tagliento, Brian Stall, James Casey, Richard Mooney, and Peggy Van Dyke), Ed Finlan, Thomas Capuano, Diane Hutchinson, the Rensselaer School District, Claire Dalton, Marianne Ogren, James Marvel, Martin Pickands, Doris Roberts, Frank Ginter, Virginia Vallee, Helen Howe, Rita L. Pont, Doris A. Walther, James Greenfield, William and Joan Senter, Joseph Grimaldi, Mary Cramer, Kevin Franklin, Nancy Hardt, John N. Gavin, William Lyons, and David Baker. A great appreciation is expressed to my wonderful acquisitions editors at Arcadia Publishing, Caitrin Cunningham and Remy Thurston.

Unless otherwise noted, all images appear courtesy of the Rensselaer City History Research Center, which includes photographs on loan from the City of Rensselaer Historical Society.

INTRODUCTION

In 1630, Kiliaen Van Rensselaer (c. 1580–1643), a diamond and pearl merchant in Amsterdam, the Netherlands, was granted a vast tract of land in what now includes the seven-square-mile city of Rensselaer. This grant from the Dutch West India Company, the first stock company in the world, gave Van Rensselaer title to the land after he purchased it from the Native Americans. This amounted to about 700,000 acres located on both sides of the Hudson River. This entire area was called Rensselaerswyck.

The first known European living in the area was Roelof Jansen (Jansz) van Masterladt, a farmer of a tree farm prior to 1630. Gerrit Teunissen de Reue, who also had been appointed *schepen* (sheriff), succeeded in owning the farm in 1634. It is possible that there were some Dutch settlers in this area as early as 1624. Originally, Van Rensselaer named the area now comprising part of the city of Rensselaer "De Laet's Burg" for Johannes de Laet, a historian, Van Rensselaer's friend, and a director of the Dutch West India Company. The Mohican name for the area was Semesseeck.

In 1632, Van Rensselaer ordered that a gristmill and sawmill be constructed on De Laet's Creek (later called Mill Creek), followed in 1642 by a brewery. Also in 1632, Laurens Laurensz was identified as a miller on what is now called Mill Creek. This creek was called Poetanock by the Native Americans and De Laet's Creek by the Dutch and included a noteworthy waterfall that can still be seen today. It is probably the oldest industrial site of the 13 original colonies. A ferry was established in 1642 and departed the east side of the river probably at what is now the foot of Aiken Avenue. Later, the community was called de Groenen Bosch (or t'Greyn Bos), or Greenbush in English (referring to pine trees). In 1642, Kilean Van Rensselaer ordered that a house be constructed for the Reformed minister Johannes Megapolensis to be located on the east side of the river. It was Van Rensselaer's hope that the patroonship would be centered on the east side of the river. This did not happen, since the population gravitated to the environs of Fort Orange (now Albany) on the west side of the river.

The city of Rensselaer is located in Rensselaer County. The county was created in 1791 from Albany County, established in 1685. When the New York State Legislature established the county, it created the township of Rensselaerswyck, which in 1795 became the township of Greenbush.

Crailo ("crow's wood") was named after the estate that the Van Rensselaer family owned in the Netherlands and was one of the New World residences for the Van Rensselaer family; it appears to have been built between 1662 and 1663, with many later alternations and additions. A recent dendrochronological examination of one of the beams in the building dates it to 1707. This beam is from a fireplace that was probably added in the cellar. Although it was a residence, it is sometimes called Fort Crailo, because during the early years it had a stockade enclosing the property to protect the residents from attacks. It was here, where soldiers were stationed during the French and Indian War in 1758, that some of the mocking lyrics to the patriotic song "Yankee Doodle" were written. These verses were said to have been written by British surgeon Dr. Richard Shuckburgh while he was sitting on a stone wall or well. The grounds of Crailo were used as a campground for British and Colonial troops. The building was expanded in 1762. This house was

located south of and outside of the municipal limits until part of the town of East Greenbush was added to the city in 1902. It was declared a National Historic Landmark in 1961 and is listed in the National Register of Historic Places.

Another important house, just south of Crailo near what is now the Port of Rensselaer, was Wolvenhoeck, built in 1724 by Petrus Douw. The house was known to contain very fine furnishings, including silver, fabrics, and paintings by Frans Hals. It was torn down and replaced in 1835.

During the Revolutionary War, Gen. Henry Knox brought cannons destined for Boston though the area. The cannons were brought across the frozen Hudson River by sled at a location near where Aiken Avenue meets with the river.

Early roads were important in the settlement of this area. In 1676, a road was ordered built from Kinderhook to Greenbush (20 miles northwest). Later, it was called the Post Road and continued south to New York City. In 1723, a new highway was built from Kinderhook along the river to Greenbush. The road east from Kinderhook to Boston was called the Great Western, or Wagon, Road and was constructed in 1735. In the 18th century, Albany Road ran from Bath-on-the-Hudson to Boston. In the approximate location of this early route, a turnpike from Bath-on-the-Hudson to the east was established in 1804. Later, part of this roadway was made into a plank road. A highway called Farmers Turnpike traveled from Greenbush to Bath-on-the Hudson and is now Broadway.

William Akin (later spelled Aikin or Aiken), with partners Titus Goodman and John Dickinson, purchased land from the estate of John J. Van Rensselaer in 1810. Goodman and Dickinson failed to pay their share of the land, and Van Rensselaer sued to reclaim the land. He was not able to do so because Akin had paid his share, but Van Rensselaer apparently did receive part of the land back. The price for the entire land purchase was $60,000. After this purchase, Akin began to subdivide the area into building lots. Akin's plot was a square mile covering the area from what is now Aiken Avenue north to Partition Street. At the time of the 1810 purchase, there were only four structures within the square mile. For some time, it was called "Akin's Mile Square." By 1813, there were 50 buildings in this location. This area became the village of Greenbush, which was incorporated in 1815. In 1897, the village of Greenbush and the township of Greenbush became the city of Rensselaer. Previously, in 1855, the towns of North and East Greenbush had already been established by removal from the town of Greenbush. Thus, from 1855 to 1897, the village of Greenbush and the township of Greenbush occupied the same geographical area.

The village of Bath-on-the-Hudson, located about a mile north of the village of Greenbush, was incorporated in 1874 by the New York State Legislature (although it was incorporated earlier by the Rensselaer County Board of Supervisors) and thereafter was annexed to the city of Rensselaer in 1902. Patroon Stephen Van Rensselaer III had established a village in Bath-on-the Hudson in the 1790s. Before 1800, a door and sash factory and oil mill were located in the village. It was originally called Bath because of mineral springs. In the 18th century and early 19th century, it became a popular destination for tourists seeking the health benefits of the mineral waters. Later, it was called Bath-on-the-Hudson in order to distinguish it from the village of Bath in Steuben County. It was the site of the northern ferry to Albany. The north end of the current city of Rensselaer was also was the location of the house and office of Casper Pruyn, the East patroonship agent for William Patterson Van Rensselaer, one of the sons of Stephen Van Rensselaer III. Beginning in the 1839, this was the location where farmers would pay to Van Rensselaer their rent in cash, produce, and livestock.

Beverwyck, the house of William Patterson Van Rensselaer—who was the director for eastern Rensselaerswyck Manor—was begun in 1838 and is now part of St. Anthony on the Hudson Monastery. The house was designed in an Italianate style. Other important structures in the Bath-on-the-Hudson area include the Wood's House, a stone structure similar to many found south in the Hudson Valley, built in the 1740s. There exists in this neighborhood a 1790s tavern and another c. 1790 house, the home of the north ferry captain.

Beginning in the 19th century, Greenbush became an important railroad center, reputed to be the busiest east of Chicago. The Albany & West Stockbridge Railroad began in 1841. The Troy

& Greenbush Railroad began in 1845. The Hudson River Railroad was established in 1851 and traveled between Greenbush and New York City. In 1900, the Boston & Albany Railroad merged into the New York Central. The area around the railroads was called East Albany, although it was mostly within the corporate limits of the village of Greenbush and later the city of Rensselaer. Abraham Lincoln traveled via train though the village on his way to Washington, and his body returned through the area on its way to Illinois for burial. In 1939, King George VI and Queen Elizabeth of England traveled though Rensselaer on their way to Canada. In 1968, the Albany rail passenger station was established in Rensselaer. A new station was built in 2002. Today, the Amtrak station located in Rensselaer serves the entire capital district area. Arcadia has published a fine book by Ernie Mann entitled *Railroads of Rensselaer* that is exclusively focused on the railroads of Rensselaer.

In 1882, the Hudson River Aniline and Color Works built its first plant in Rensselaer. However, at that time, it was physically located with the limits of the town of East Greenbush, since this area was not annexed to the city of Rensselaer until 1902. In 1903, the Bayer Corporation acquired it. That company built the first aspirin factory in America here. The US government seized the property in 1917 as enemy property, since the Bayer Company was owned by a German concern. Soon after, Sterling Winthrop purchased the factory. At one time, as many as 1,600 people were employed at the Sterling facilities. BASF later acquired the factory. In 1927, it became the first factory to produce solid diazo salts in the United States. In 1978, it employed 525 employees. In the 1990s, it produced more dye, including the blue for Windex and yellow for Post-it Notes, than any other factory in the United States, but in 2000, the plant was permanently closed.

Another major factory in Rensselaer was the F.C. Huyck and Son's Kenwood Mill, which operated from 1894 until the 1990s. It produced woolen blankets and felts that were necessary for papermaking. In 1911, it pioneered establishing sick benefits and pension plans for its employees. Parts of the Huyck complex are now the offices for the New York State Office of Children and Family Services.

The private Rensselaer Water Company provided city water by filtering Hudson River water beginning in 1887. Since 1968, the City of Rensselaer has purchased water drawn from the Tomhannock Reservoir from Troy. In 1886, the sewer system in Greenbush Village was initiated.

Many industries existed in the 19th century, with many of the buildings still existing. Fred Carr, Steam Cracker and Biscuit Manufactory began in the 1820s, and the building still exists at 17 Second Avenue. Other industries included Barnet Shoddy Mill (*shoddy* is a rough reclaimed and chopped wool), a shirt factory, Smith's Jew's harp manufacturer, a chain maker, papermaking, coal distribution, many mills, ice harvesting, brick making, and shipbuilding. Shipping activities were an important part of the commerce, especially in the 19th century. The USS *Narcissus*, which participated in the Civil War, was constructed in East Albany (Rensselaer). Of course, there were many businesses and activities associated with the railroads in the northern part of the village of Greenbush. There were farms, hotels, retail stores, banks (the first one was started in 1831), and related businesses within the city.

The city of Rensselaer is located on the Hudson River, which is considered to be a tidal estuary until it reaches Troy; the water level changes several times a day with the changing tides. The river and its commerce were an essential part of the city's activity. Crossing the Hudson River to reach Albany and the west was important. Prior to 1866, all passengers traveling to Albany took a ferryboat. The first bridge was a railroad bridge built in 1866. A second railroad bridge was built in 1871. These spans did allow foot traffic. The first passenger traffic bridge was built in 1882. In 1932, a new Rensselaer bridge replaced the 1882 span. The Patroon Island Bridge, which carries Interstate 90 over the Hudson, was opened in 1969. That year, the current Dunn Memorial Bridge was also built. In order to allow river traffic, the bridges built prior to 1932 were swing bridges, and the 1932 bridge was a lift bridge.

In 1932, the Port of Rensselaer was established as an east-shore subsidiary of the Port of Albany. The docks at the Rensselaer Port were added in the 1970s. The 42-acre site of the National Guard rifle range was established in 1880 in a deep ravine in the northeastern region of the city, and it

continued in use until the 1950s. The island in the river in front of the village was called originally De Laet's Island and later Van Rensselaer's Island. In 1903, the channel that separated the island from the eastern mainland was filled in with sand dredged from the Hudson.

Some notable people in Rensselaer, either by birth or event, left their marks on the city. Edmonia Lewis, the first major African American sculptress of international renown, was born here. An agent for the Underground Railroad lived in the Aiken house prior to the Civil War. Henry Wilkes, a sailor who served in the Civil War, was awarded the Congressional Medal of Honor and is buried in the city's Beverwyck Cemetery. In 1824, the General Marquis de Lafayette visited the village and was given a large parade, for which a temporary arch was erected over Broadway.

Social institutions have included a Masonic society that was established in 1814 and continued until the 1820s. Another Masonic lodge was established in 1853. Later, there were active Odd Fellows and Pythian lodges as well as various organizations related to the needs of the railroad employees. Fire companies were very numerous, having been required by the Greenbush Village Charter of 1871, and were centers of considerable social activity, including participation in parades, balls, and other events. Groups such as the Rensselaer Mother's Club, Kiwanis, Knights of Columbus, Fraternal Order of Eagles, and the Shakespearean Society provided additional social, charitable, and cultural outlets. The Boys and Girls Club was established during the 20th century and is very active to this day. Veteran's groups such as the American Legion and VFW continue to be active within the city.

The earliest record of a public school in Rensselaer is from 1813. There were schools located in Greenbush and Bath-on-the-Hudson. In the 1840s, a private school existed in the building now known as the Crailo State Historic Site. A parochial school and an orphanage, associated with and near St. John's Roman Catholic Church, were established late in the 19th century.

During the 18th century, the Dutch inhabitants attended the Reformed church located at some distance from the present city limits. The first churches in the city proper were the Presbyterian church, established in 1823, and the Methodist church, begun in 1833. Other churches were started in the 19th century, including a Methodist church in Bath-on-the-Hudson and an Episcopal church in 1851. St. John's Roman Catholic Church was established in 1850. Baptist, Reformed, Congregational and Lutheran churches were also organized in the 19th century. The city has also seen the establishment of Sikh and Buddhist religious communities.

The city of Rensselaer continues to be active, with many businesses, new houses, civic groups, new construction, and a clear sense of community. The area in and near the Port of Rensselaer continues to add industrial activities such as new power plants and a recycling facility. The city's population numbers rose in the 2010 Census.

One

THE HUDSON RIVER

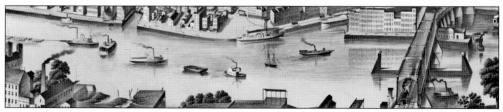

This lithograph is from a map of Albany published in 1879 by H.H. Rowley and Company. The top section shows part of the city of Albany, while the bottom shows the shoreline of Greenbush (Rensselaer). The swing railroad bridge was constructed in 1872. Steamboats would often have barges in tow, as seen to the left. (Courtesy of the Albany Institute of History and Art, Gift of National Savings Bank, 1971.14.1.)

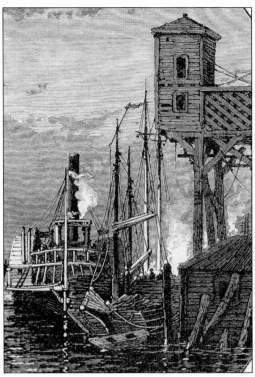

This is a wood engraving of the Greenbush Slip. It is from *Picturesque America*, published in 1872. This is a place where barges and boats would dock in Greenbush.

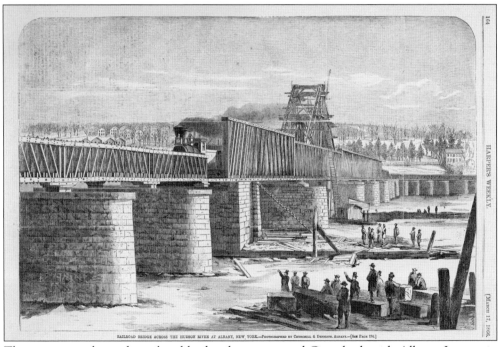

This engraving shows the railroad bridge that connected Greenbush with Albany. Its cost in 1866 was $750,000. The image is from the March 17, 1866, *Harper's Weekly*. This railroad bridge was the first bridge between Albany and the eastern shore of the Hudson River. This is now the location of the Livingston Avenue Bridge, which utilizes the same supports.

The Hudson River was used for pleasure boating. Here is an excursion boat as it travels on the river. The image dates from about 1920.

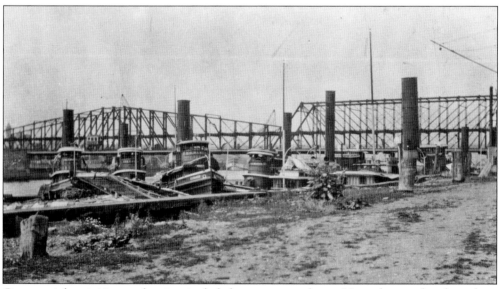

Commercial activities on the river included numerous tugboats. Here, they are lined up along the shore. The bridge is the Greenbush Bridge, constructed in 1882. The city of Albany is seen in the distance in this photograph from about 1910. (Courtesy of Ernie Mann.)

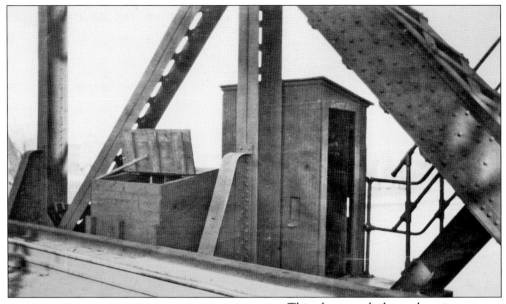

This photograph shows the privy on the freight, or northern, bridge (now the Livingston Avenue Bridge) that was operated by the New York Central Railroad.

Likewise, here is the sentry box on the New York Central passenger train bridge, or lower bridge. Both photographs were taken in 1918.

For many years, the river shore has been the location for industry and manufacturing. This photograph would date to the 1940s. It appears that the location was Carner's Terminal at 1 Central Avenue.

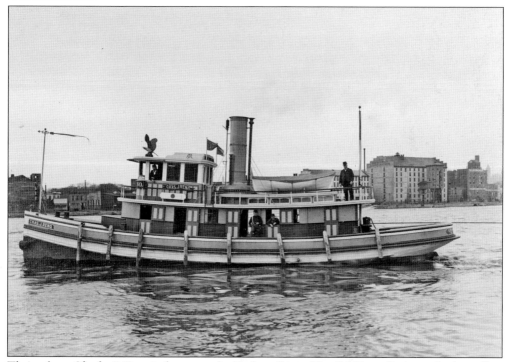

The tugboat *Charles J. Reno* is shown on the Hudson River. The C.J. Reno Company had its office at 63 Broadway, which was destroyed in the 1906 fire. Charles Reno also owned a coal company that later became his main business. This photograph dates from 1910–1915. A photograph of Charles Reno appears on page 116. One can see one of the problems of ship traffic on page 19. (Courtesy of Ernie Mann.)

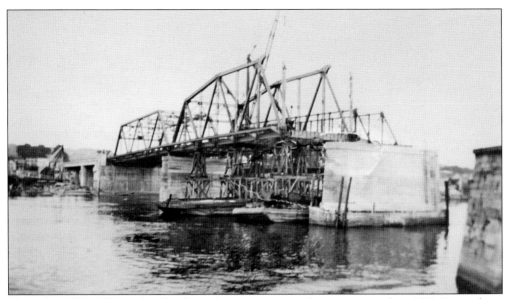

Here, the Albany-Rensselaer Bridge is being constructed; it was opened in 1933. It was later named the Pvt. Parker Dunn Memorial Bridge after a hero of World War I. This $3-million bridge replaced the Greenbush Bridge of 1882. Visit page 102 to see what can happen when there is careless driving on the bridge.

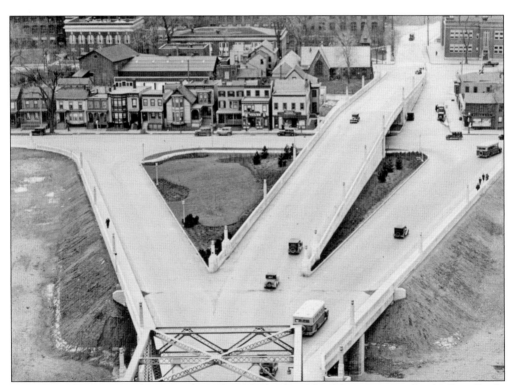

This shows the ramps to the Rensselaer side of the bridge. Third Avenue passes by the Fort Crailo School. Huyck Mills is seen on the left in this photograph dated to about 1935.

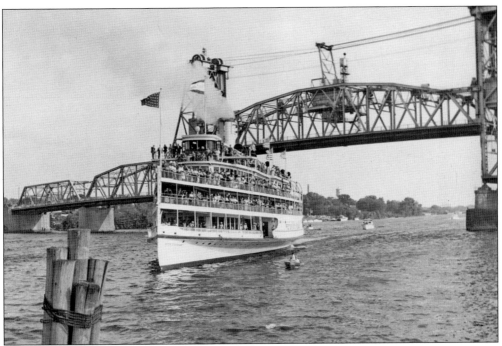

The Hudson Dayliner line traveled to New York City, and one of its boats is shown beneath the raised Dunn Memorial Bridge during the 1930s.

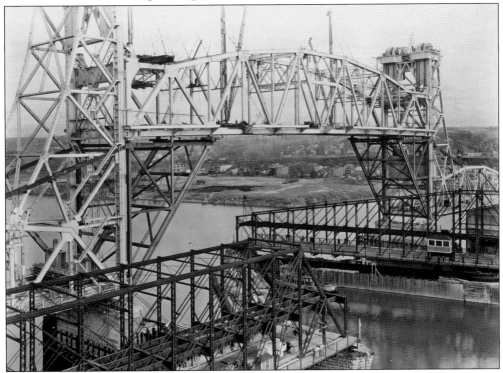

This rare view shows the Greenbush Bridge (front), which would soon be demolished, and the new Albany-Rensselaer (Dunn Memorial) Bridge in 1933. (Courtesy of New York State Library.)

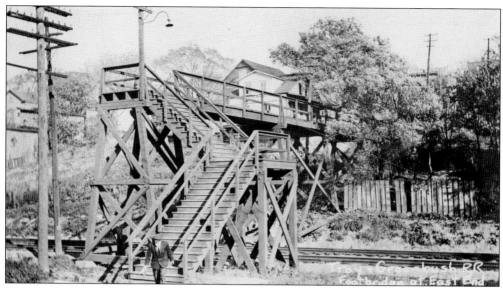

This wooden bridge connected the city with the shoreline. This was for foot traffic for traveling over the railroad tracks.

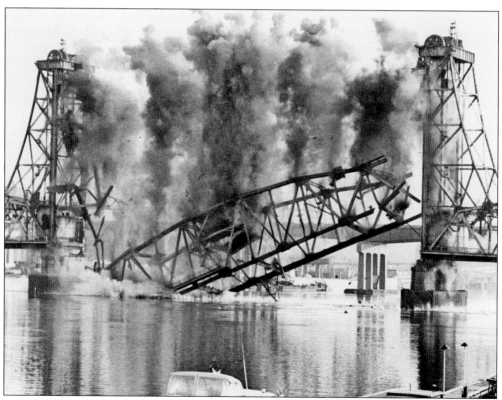

In 1971, the old Dunn Memorial Bridge was demolished. The new Dunn Memorial Bridge is seen in the rear. (Courtesy of Jack Schumaker.)

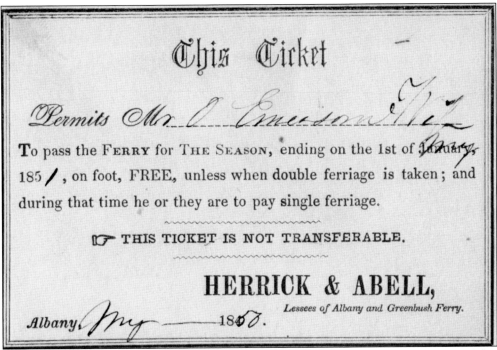

This Ticket

Permits Mr. O. Emerson Ph.

To pass the FERRY for THE SEASON, ending on the 1st of January, 185/, on foot, FREE, unless when double ferriage is taken; and during that time he or they are to pay single ferriage.

☞ THIS TICKET IS NOT TRANSFERABLE.

HERRICK & ABELL,
Lessees of Albany and Greenbush Ferry.

Albany, *May* —— 1850.

Prior to 1866, the use of ferries was the only way to cross the river. This is a ticket dated 1850 for use of the ferry between Albany and Greenbush. This pass was issued to Rev. Oliver Emerson, a Methodist minister who had served a church in Greenbush.

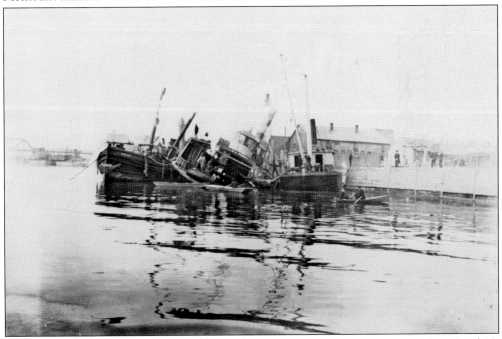

The sinking of the Bath-on-the-Hudson–to–Albany ferry *Maid of Perth* occurred on April 10, 1902. The tugboat *Reno*, while sailing on the river with two barges, rammed into the ferry. For a view of the tugboat, see page 15. (Courtesy of Ernie Mann.)

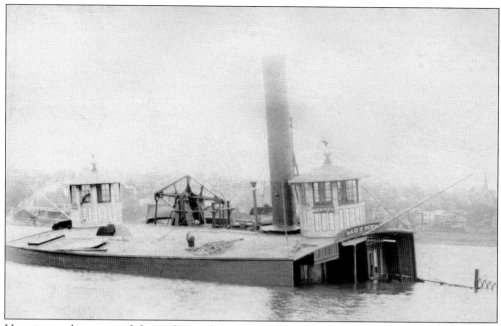

Here is another view of the sinking of the *Maid of Perth* ferryboat. Notice that the ferry is partially submerged.

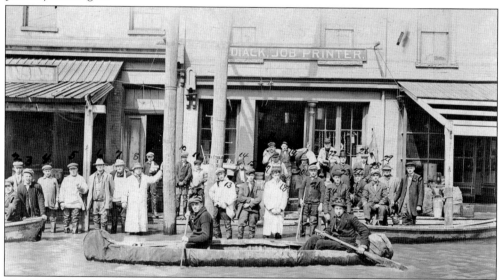

The Hudson River would occasionally overflow and cause floods in Rensselaer. This image shows a view of Broadway during the 1913 flood. Alexander Diack had a printing firm located at 223 Broadway. Shown are (No. 1) Matt Mittler, (No. 2) Bud Lansing, No. 3) Dick Strohmaier, (No. 4) Stanley Cockingham, (No. 5) Elmer Cote, (No. 7) Cooney Wagner, (No. 8) Fred Lawen, (No. 9) Arthur Bruso, (No. 10) William Signer, (No. 11) Schermerhorn, (No. 12) Ed. Godfrey, (No. 13) White Cote, (No. 14) Willie Gilligan, (No. 15) Heine Letzeller, (No. 16) Bill Albright, (No. 17) Lew Fisher, (No. 18) Frank Pratt, (No. 19) John McCarthy, (No. 20) Bert Elliot, (No. 21) Willis Boyce, (No. 22) Jack Kline, (No. 23) George Wiltse, (No. 24) Peter Smith, (No. 25) Leonard Kirsch, (No. 26) Fred Gaul, (No. 27) Frederick Carr, (No. 28) Fred Lozon, (No. 29) Roy Irving, and (No. 30) James Hitchcock. (Courtesy of Ernie Mann.)

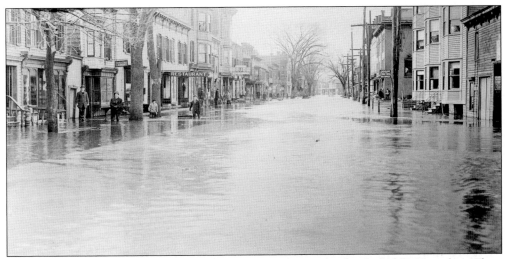

Here is Broadway looking south from Third Avenue during the flood of 1913. Humphrey Flats, an apartment house, is shown on the right, and Stewarts Drug store is on the left. The restaurant of James H. Green was located at 260 Broadway, and Charles Chung's Laundry can be seen at 266 Broadway. A little further south, one can see the post office (see page 60), and next to the apartment building is Miles Machine Shop (see page 103).

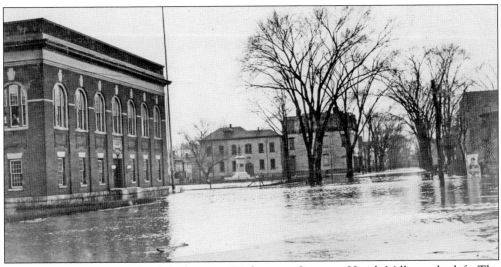

Also shown in the 1913 flood, looking up Washington Street, is Huyck Mills on the left. The flood occurred from March 27 to March 29. The Soldiers and Sailor's Monument, which was dedicated in 1910, is in view. In the rear, the old School No. 1 can be seen.

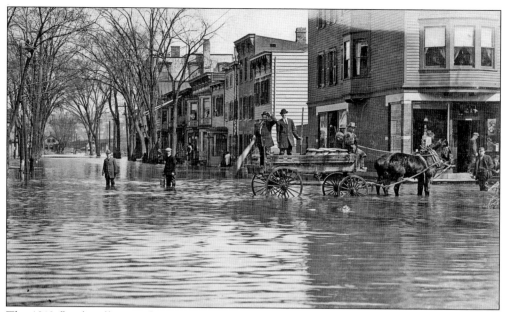

The 1913 flood is illustrated again. This photograph shows the intersection of Second Avenue and Washington Street. James Guilfoil's grocery store, at the right, is at 21 Second Street. One can see milk being delivered in the wagon. The 1913 flood was one of the worst in the area's history, with the river rising 22 feet above normal at Albany.

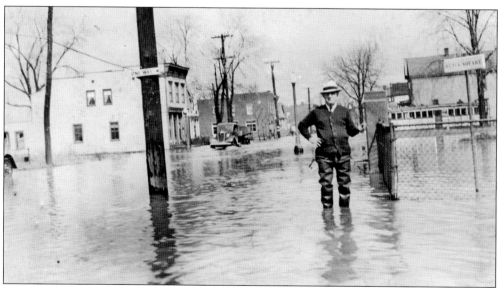

Huyck Square is shown in this view of the 1913 flood. One can see a trolley car in the background. The *Times-Union* reported that trolley service was paralyzed. Residents needed to walk to Albany in order to reach work. (Courtesy of Ernie Mann.)

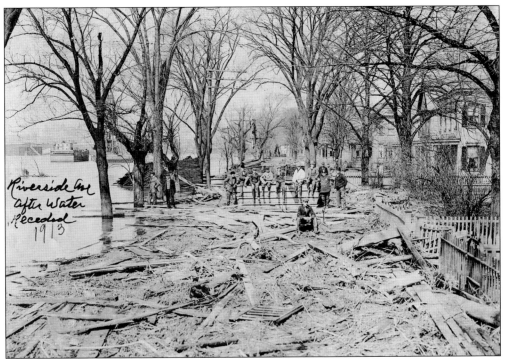

Riverside Avenue is shown following the 1913 flood. The water was two feet deep on Columbia Street. Flooding basically ceased after flood control was put into place in the mid-1920s. (Courtesy of Ernie Mann.)

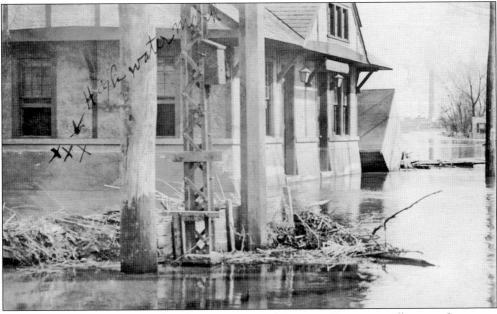

This image from the flood of 1913 shows the United Traction Company trolley transfer station located on Broadway and Third Avenue. The back of this postcard is inscribed, "Will try and write a few days. This shows you something of the flood. This was taken as the water was going down. Milo, the Boy." The postmark is dated April 16, 1913. (Courtesy of Ernie Mann.)

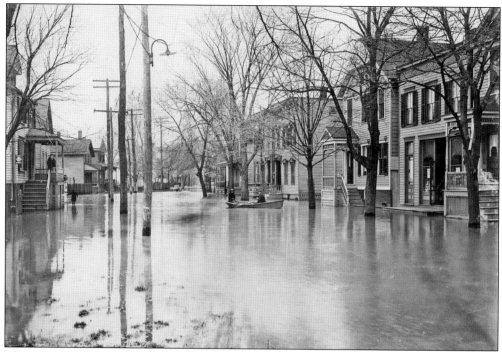

This view shows the April 13, 1922, flood on Nelson Avenue. In August 1922, the Hudson River Regulating District was established in order to prevent future floods. (Courtesy of Ernie Mann.)

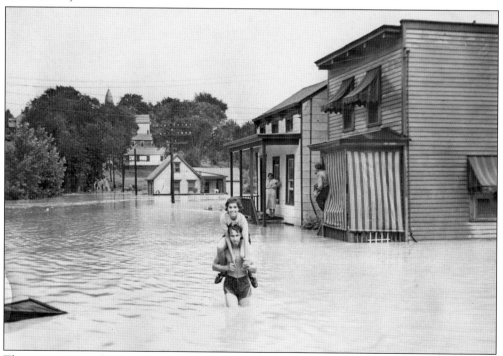

This is in vicinity of Willow Street during the flood that occurred on July 7, 1938. The flooding in this area was caused by the overflowing of the Quackenderry (also spelled Quackendary) Creek.

Two

Rensselaer's Schools

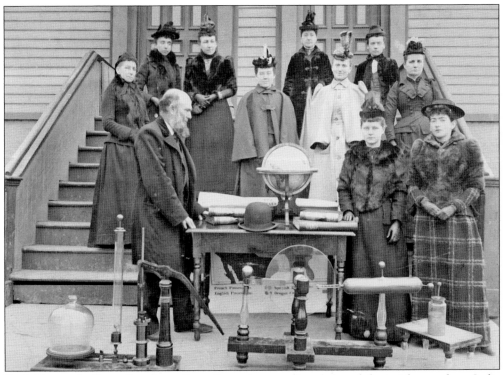

Prof. George A. Quay (for whom Quay Street is named) and, from left to right, teachers Sadie Champin, M.A. New, Emily Aston, Elizabeth Stever, Anna Wygant, Mattie Jones, Julia E. Brown, Sarah Bell, Ida Taylor, and Hattie Quay are standing in front of the school at Bath-on-the-Hudson. This was taken about 1890.

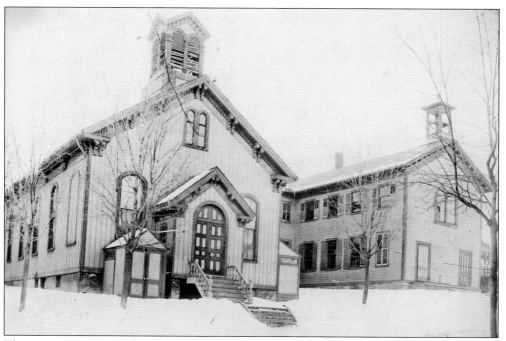

This is a winter view of the public school, which was built in 1849 at Bath-on-the Hudson. The section on the left was a Methodist church before being added to the school. Part of the building also held the high school. School No. 3 was built on this site in 1897.

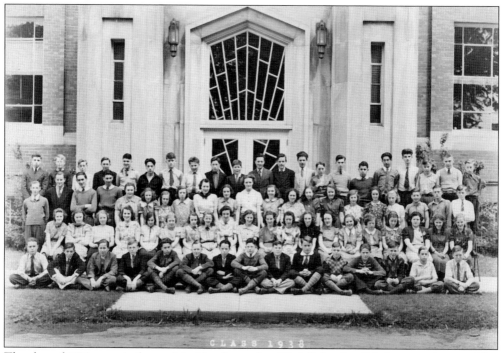

The class of 1938 poses in front of the Van Rensselaer High School on Washington Avenue. The building is now a private interfaith school, the Doane Stuart School. The structure is listed in the National Register of Historic Places.

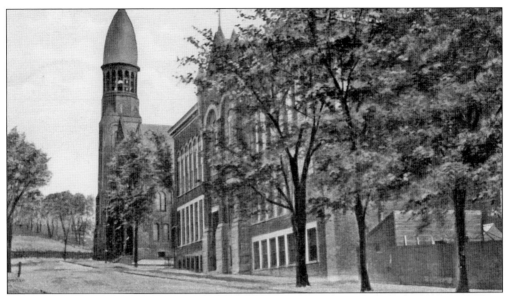

Golden Jubilee Hall of St. John's Academy was open for students in 1903 and is shown in this c. 1910 photograph. It was named in honor of the 50th (golden) anniversary of the founding of St. John's Parish and was located on Herrick Street.

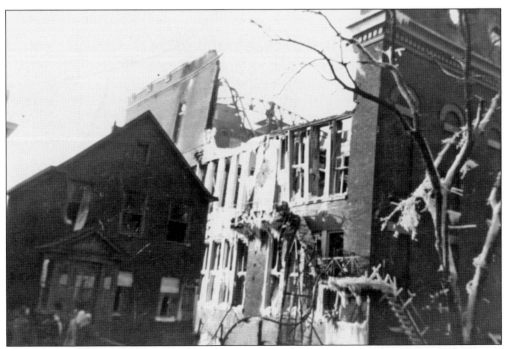

The Golden Jubilee Hall burned on March 11, 1950, with an estimated loss of $300,000. Here, it is shown after the fire, which started near the second-floor laboratory, was extinguished. The fire was such that fighting it required assistance from nearby fire companies in East Greenbush and Albany. After its destruction, a new building was constructed. The school closed in the 1970s.

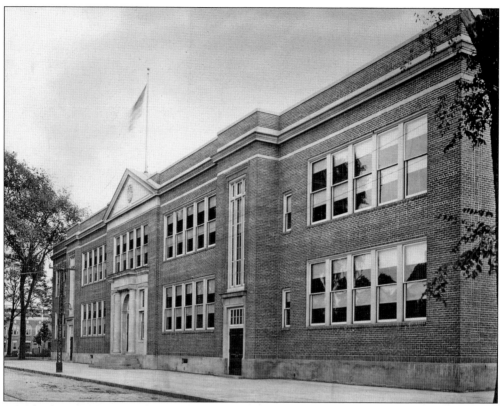

Fort Crailo School on Washington Street was built in 1916 and was also called School No. 1. It was a grammar school and replaced an earlier School No. 1. The building is now Rensselaer City Hall, which also houses the Rensselaer City History Research Center.

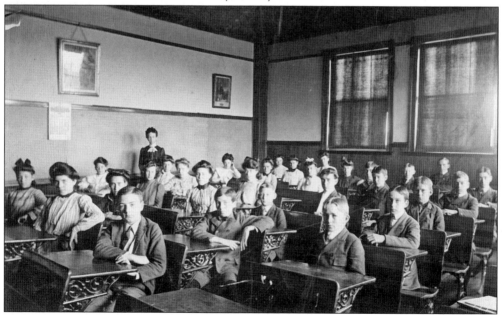

Shown here is a classroom, probably in Bath-on-the-Hudson. The photograph is dated 1903.

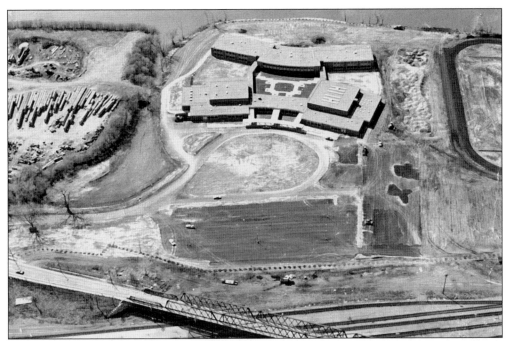

Here is an aerial view of Rensselaer Junior Senior High School, which was built in 1971. It was located on the former Van Rensselaer Island. It has since been removed, and a new school containing all of the grades has been built at the northern end of the city.

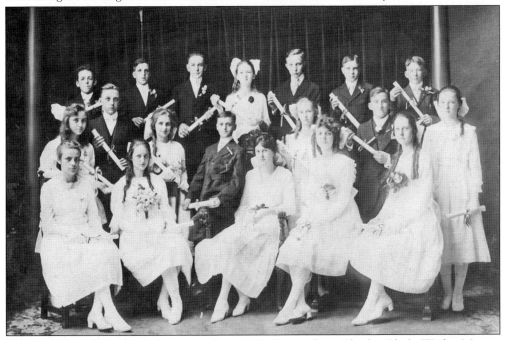

This is the eighth-grade graduation in June 1918. Pictured are Charles Clark, Wesley Mason, Richard Septer, Louise Neylson, William Faas, Kenneth McFarland, Louis Van Dyck, Myrtle Powell, ? Drumn, Florence Conner, William Cummings, Alice Neylan, John Reuter, Alice Cross, Marie Septer, Gwendolyn Tompkins, Susan Moore, Aida Crissey, and Dorothy Ackley.

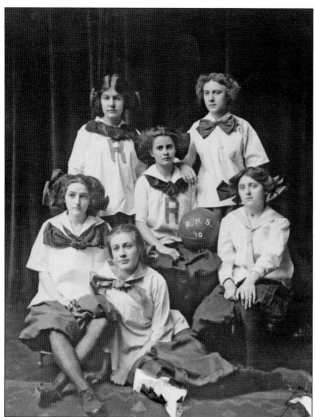

This is a portrait of the first Rensselaer High School girls' basketball team in 1910. Pictured, from left to right, are (first row) Irene Nusbaum, Marion Gray, and Lillian Farrell; (second row) Ada Parnell, Hazel Bleau, and Helen Gray.

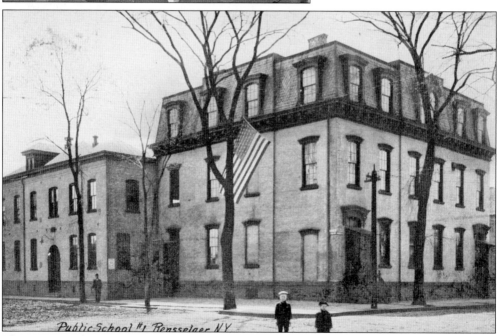

This is a view of Rensselaer Public School No. 1 from around 1910. It was located on Washington Street at the future site of the Fort Crailo School.

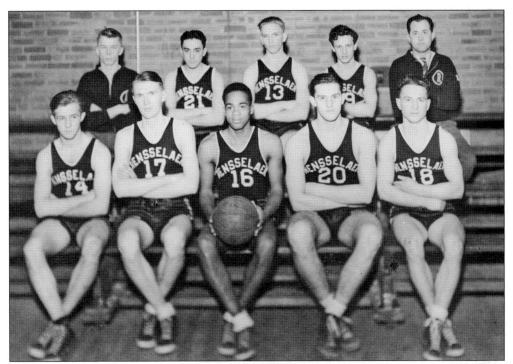

A 1940–1941 photograph of the Rensselaer basketball team is shown here. The coach was Bob Bruckner. The identified players are Ken Wheeler (No. 17), Harry Holton (No. 20), Rob Mason (No. 16), Vince Kenaka (13).

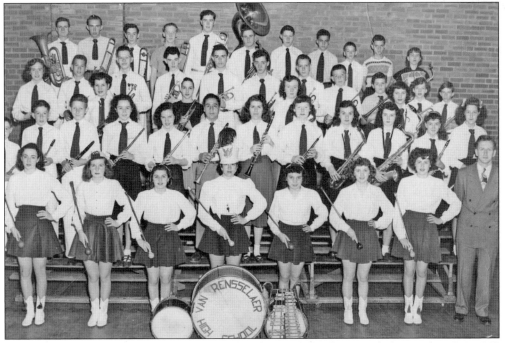

The Van Rensselaer High School marching band poses for a photograph during the 1947–1948 school year.

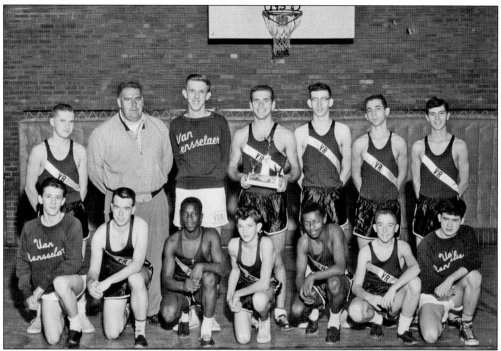

This is the 1958 Section 2, Class C, New York State Public High School Athletic Association champion basketball team of Van Rensselaer High School. The coach was Thurston Thompson.

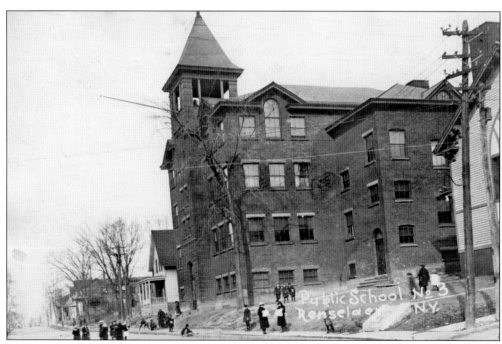

Pictured is School No. 3, which was next to Broadway Methodist Church on Broadway. It was built in 1897 as the East Albany School. The structure was destroyed by fire.

Three

FIRES AND FIREHOUSES

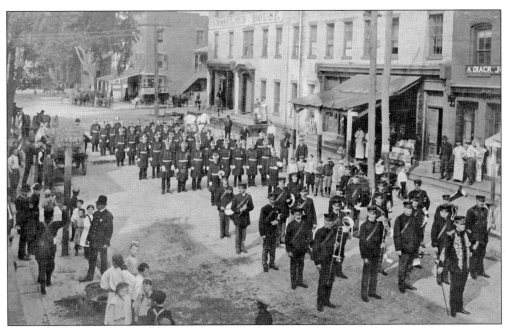

The J.N. Ring Fire Company is marching in a parade on Broadway. The Rensselaer House was located on the land that now has the Rensselaer Police Station, formerly the post office. The sign on the left is for Duff's Livery, which was located at 228 Broadway. The fire company was founded in 1872 and was named for James N. Ring, a prominent merchant and civic leader.

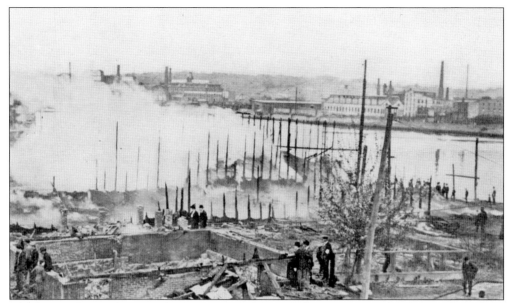

The largest fire in the city's history occurred on October 6, 1906. It began in a huge barn owned by Charles J. Reno that was filled with hay. The fire spread to nearby coal yards. The location was near the current Albany Yacht Club. A total of 31 buildings were destroyed, with an estimated loss of $146,450. The fire occurred in the area of Broadway south of Columbia Street. Buildings on Broadway, Columbia Street, and Academy Street and structures on the waterfront were destroyed.

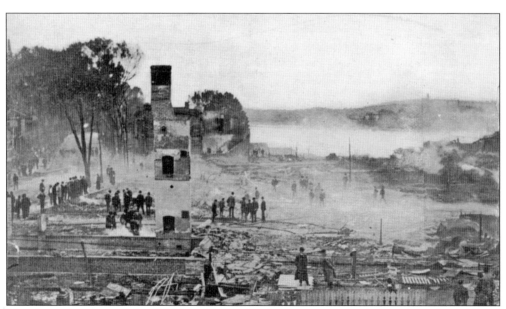

Here is another view of the 1906 fire. Many other fire companies, including those from Albany and Troy, provided mutual aid. Because of high winds, there was a considerable fear that the entire city would be burned.

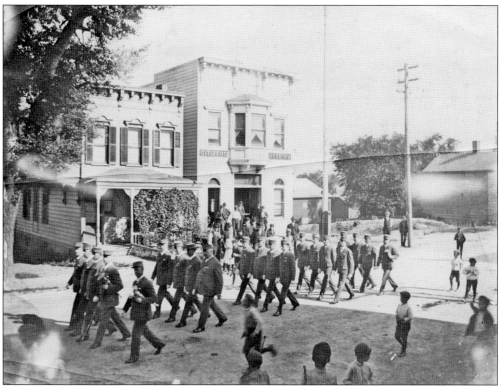

This parade is passing in front of the Citizen's Hose No. 2. The building was located at 1497 Broadway in Bath-on-the-Hudson. The company was organized in 1887. The village established a telegraphic fire alarm system in 1896.

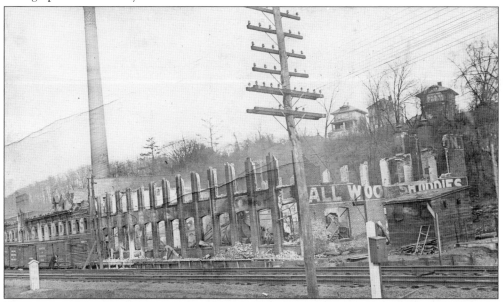

This is view of the fire that occurred on February 25, 1915, at William Barnet's Shoddy Mill. The southern part of the building was destroyed at a loss of about $50,000. The factory had been built in 1884 by John G. White for a malt house. The company continued in business after the fire.

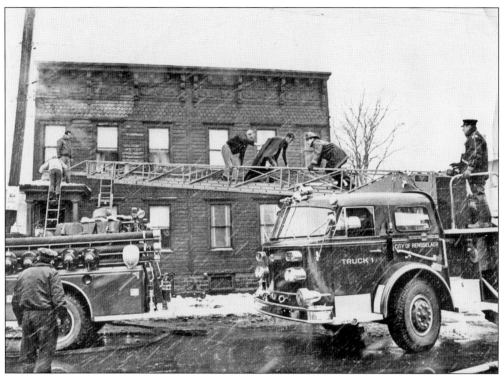

The Rensselaer Fire Department is extinguishing a fire at 487 Broadway. This was a bedroom fire in which a man had to be rescued from the house. (Courtesy of Jack Schumaker.)

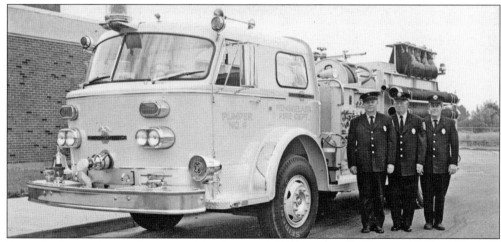

Rensselaer's new fire truck, pumper No. 4, was a 1976 American LaFrance vehicle. Shown in the photograph, from left to right, are Edward Leffler, Frank Reiley, and Fred Clark. (Courtesy of Jack Schumaker.)

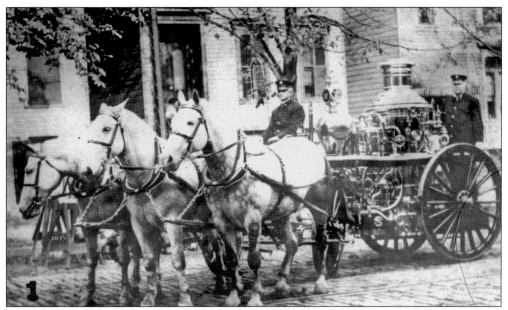

Here is a view of a 19th-century firefighting apparatus. A similar piece of equipment can be seen in the photograph on the next page.

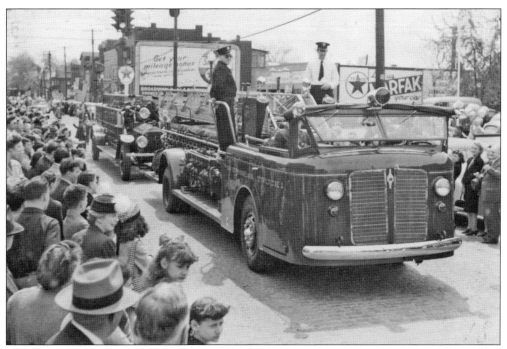

The City of Rensselaer Truck No. 1 is in the forefront in this parade view from the late 1940s on Broadway.

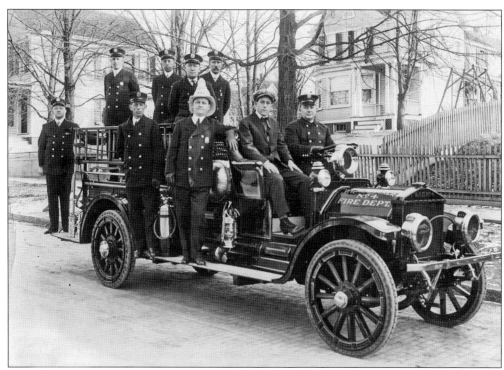

Pumper No. 4 is shown with the fire department chief and officers around 1925. Prior to 1904, all members of the fire companies were volunteers. In that year, the city hired its first paid driver for the G.S. Mink and T. Claxton Hose No. 2 at a salary of $60 per month.

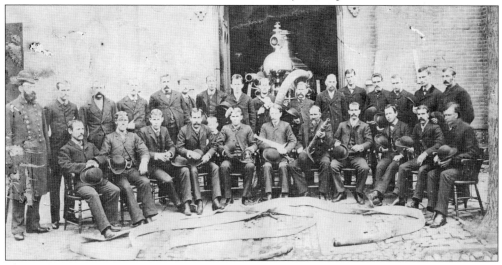

The J.N. Ring Fire Company poses for a group photograph in 1885. Pictured, from left to right, are (first row) Andrew Minkler, Marvin Pinkney, S.E. Cordial, Jack Rigney, "Little" Tim McMahon, M.A. Heeran, foreman Simeon Lodewick, E.G. Griffin, R.I. Wilson, John McMahon, Frank Carmen, and David Staples; (second row) officer William English, I.C.P. Green, John Shelley, John Condon, William Matson, Tile Miller, Charles Griffen, William McMahon, James I. Miles, John J. Byers, Henry Anthony, M.E. Dunn, W.K. Waterbury, John Knapp, Frank Hotaling, and Ira Shafer. (Courtesy of Jack Schumaker.)

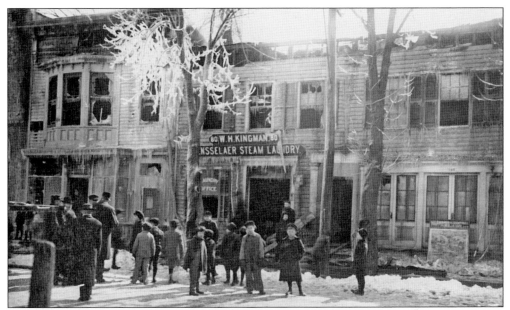

Rensselaer Fire Department is shown finishing extinguishing a fire at the Rensselaer Steam Laundry at 150 Broadway. This fire occurred on March 24, 1906. The owner of the building had not yet changed the street number. It was 80 Broadway until 1901, when it became 150 Broadway; during that year, street numbers of Broadway were changed. One can note that the building next door has the correct number of 148. (Courtesy of Jack Schumaker.)

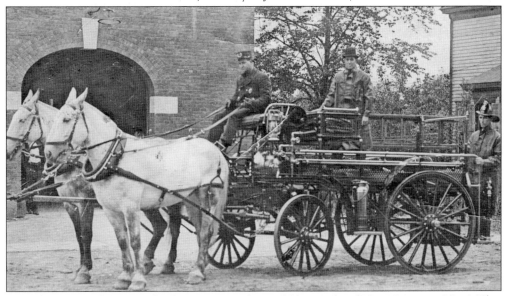

These horses are about to pull a fire pumper in front of Chemical and Hose Company No. 4. This fire company was located at 1717 Fifth Street. About 1910, this fire company was formed from the members of the J.S. Bellinger Steamer and Hose Company No. 4, W.O. Howard Hose No. 5, and C.A. Bailey Hook and Ladder No. 2. The structure had been originally the home of the J.S. Bellinger Steamer and Hose Fire Company No. 4, which was organized in 1884. This building continued as a firehouse until 1987 but is now an apartment house. This photograph was taken about 1915. (Courtesy of Ernie Mann.)

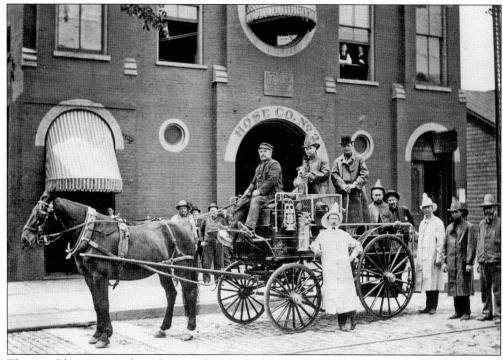

The proud firemen pose for a photograph with their equipment in front the city hall, police station, and fire department building, which was located at 959 Broadway. This was the home of the G.S. Mink Steamer Company and T. Claxton Hose Company No. 2. (Courtesy of Jack Schumaker.)

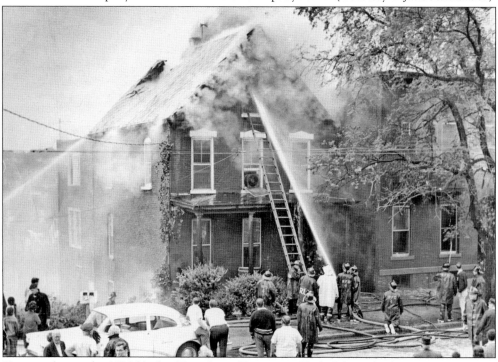

Here is a fire on the 1200 block of Broadway. (Courtesy of Jack Schumaker.)

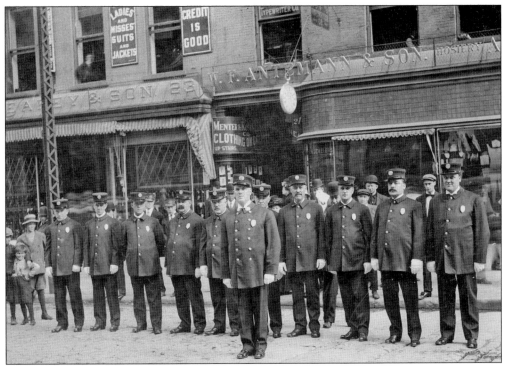

Member of the James Hill Hook and Ladder Company No. 1 pose during a parade held in Albany. They are standing in front of W.F. Antemann and Son Jewelry store, which was located at 21 North Pearl Street. The photograph was taken about 1915.

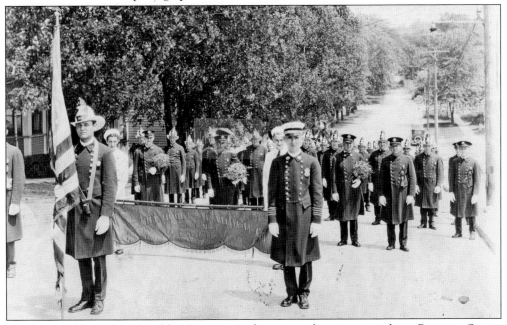

The James Hill Hook and Ladder Company is shown marching in a parade on Partition Street. The company had been organized in 1892. This photograph dates to about 1920. (Courtesy of Jack Schumaker.)

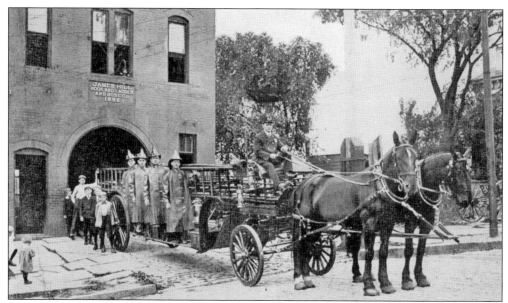

The James Hill Hook and Ladder is displayed at the fire station that was located on Partition Street. This photograph dates from about 1910. The building still exists but is now privately owned.

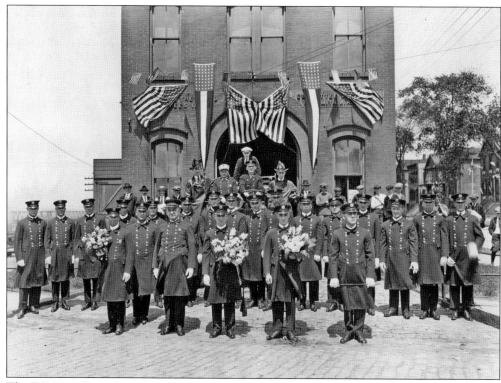

The E.F. Hart Hose Company No. 3 appears in front its fire station, which was located on East Street. The Hart Company was organized in 1887. The building still exists and is located adjacent to the Amtrak station. It is now privately owned. This photograph was taken in 1922 (Courtesy of Jack Schumaker.).

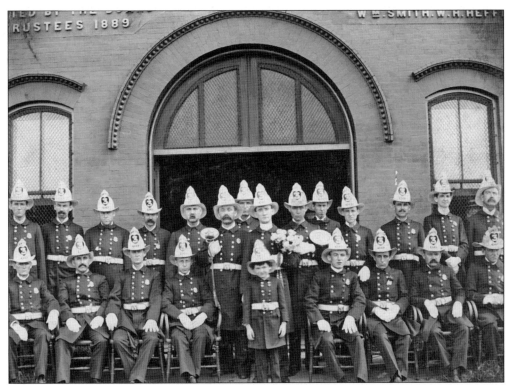

This view of the E.F. Hart Hose Company No. 3 was taken around 1900. Eugene F. Hart was the organizer of this fire company. In 1892, it had 40 officers and men. Since then, the front door has been enlarged to make room for larger trucks. The building is now privately owned. (Courtesy of Ernie Mann.)

The fire hoses are being tested around 1950.

Here, firefighters of the city participate in a parade about 1955.

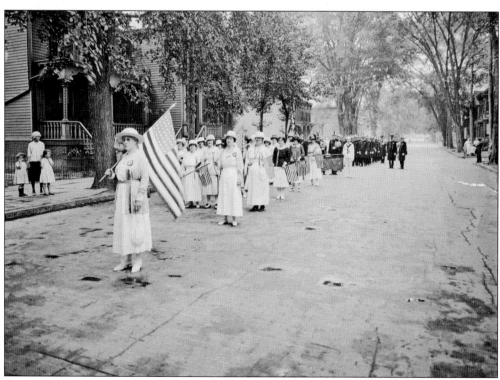

The Auxiliary Corps of the J.N. Ring Fire Company is marching about 1920. (Courtesy of Ernie Mann.)

Four

Streets, Landscapes, and Buildings

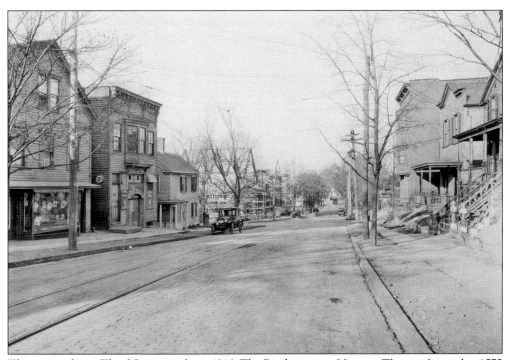

This image shows Third Street in about 1916. The Brightspot, or Uptown Theatre, located at 1575 Third Street, is visible on the right. It had previously been the W.O. Howard Hose Company. The theater was later known as the Third Street Theatre and was for many years the only theater in the capital district that showed foreign and independent films. It closed in 1986. It is now privately owned, having been sold by the city for back taxes. Next to the theater is Charles Wornham's candy store, located at 1571 Third Street. Wornham was also a chief of a fire company. In the background, framing for St. Joseph's Church can be seen. (Courtesy of the Troy Public Library.)

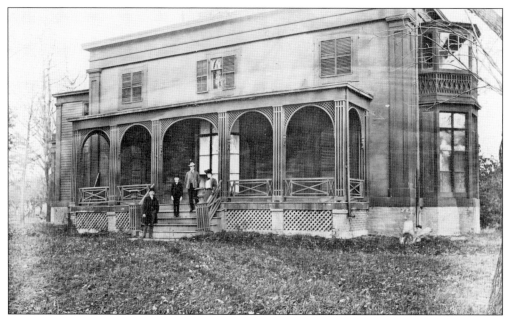

The Douw House was located at Douw's Point and was also known as Wolvenhoek. Its location was near what is now part of an oil company's property in the present Port of Rensselaer. It was built in 1835 and replaced a much earlier house. There is the unlikely legend that Captain Kidd's pirate treasure was buried a few rods south of the house. (Courtesy of Ernie Mann.)

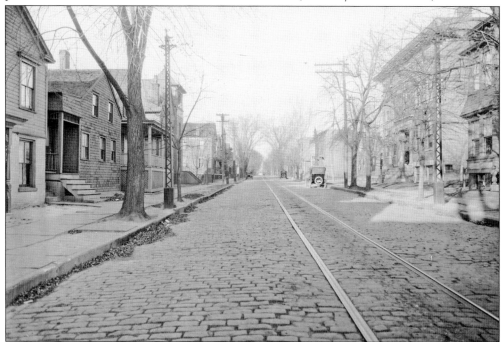

The Masonic temple, previously the home of Greenbush Lodge No. 337 of the Free and Accepted Masons, can be seen in this view of Third Street. The cornerstone for the Masonic building was laid on August 27, 1910. St. Paul's English Lutheran Church is on the right. (Courtesy of the Troy Public Library.)

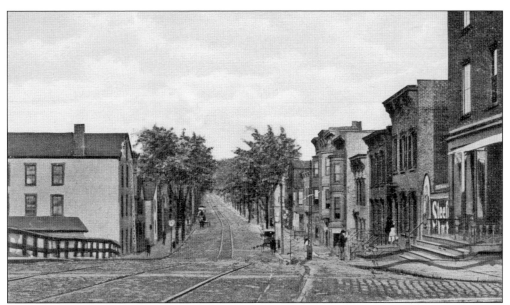

The viaduct bridge carried Broadway over the railroad tracks. It replaced a grade crossing that was the site of several accidents. This view, looking north from the bridge, was taken before 1909.

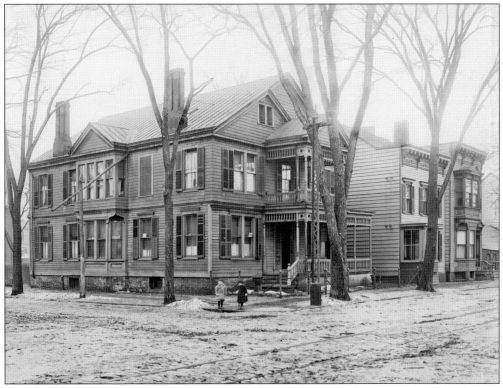

The Kilcawley house is located at 34 Washington Street near Second Avenue; Michael Kilcawley worked as a butcher and junk dealer. All three houses in the photograph still exist. The next house to the right is no. 30, and the one after that is no. 32. The photograph dates to about 1920. (Courtesy of Ernie Mann.)

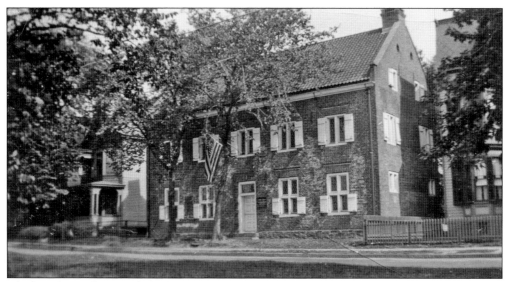

The Van Rensselaer family built Crailo, or Fort Crailo, in 1662–1663. Johannes Van Rensselaer built the northeast wing in 1762. There have been many other alterations to the structure. Part of the words to the song "Yankee Doodle" was written here. It is now a New York State Historic Site and is listed in the National Register of Historic Places.

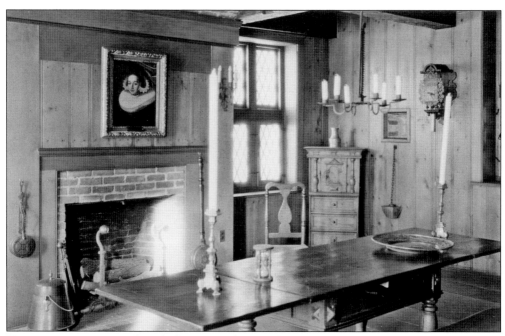

Here is an interior view of Crailo from around 1930, after New York State acquired it. The interior was designed to look Colonial but is not very accurate either for the 17th or 18th century.

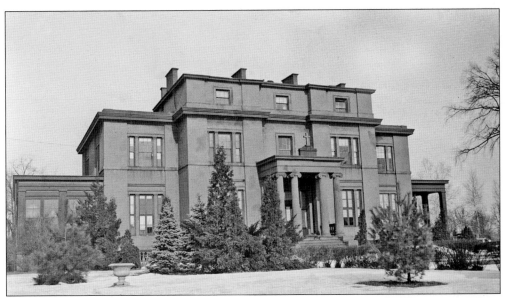

Beverwyck was built by William Patterson Van Rensselaer between 1839 and 1843, at a cost of $140,000. At the time, it was one of the grandest houses in upstate New York. The architect was the Englishman Frederick Diaper. Later, it was acquired by Paul S. Forbes and called Forbes Manor. It is now part of the St. Anthony on the Hudson Franciscan Seminary. Many priests received training here, including Cardinal Peter Turkson of Ghana. H.P. Weber took this photograph in 1934 as part of the Historic American Buildings Survey. The home is listed in the National Register of Historic Places.

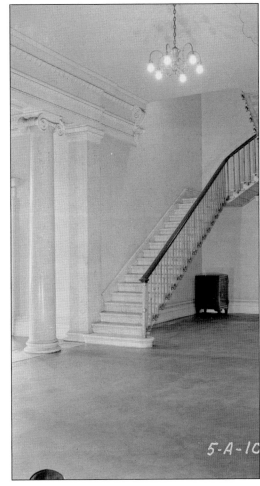

Here is an interior photograph of Beverwyck. The stairs were made of Carrera marble imported from Italy. The stair railing is of cast iron, and a faux marble column is shown on the left. This photograph was taken in 1934 as part of the building's documentation included in the Historic American Buildings Survey. (Courtesy of the Library of Congress.)

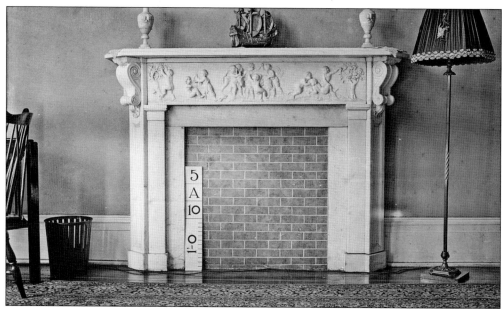

Here is another interior detail from Beverwyck, or Forbes Manor. It shows the guest room fireplace located on the second floor. It is made of Italian marble with the decoration of dancing cupids. The finest materials were used in the building's construction, with artisans imported from Italy. The photograph is from the Historic American Buildings Survey. (Courtesy of the Library of Congress.)

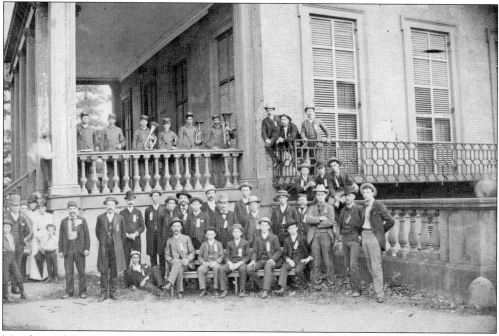

Members of the Young Men's Christian Association pose for their photograph on a porch of Beverwyck, or Forbes Manor. This photograph would have been taken before the Franciscans acquired the property in 1911. This photograph may be related to Rev. Robert H. Collins's attempt in 1905 to use the property to make a park for Sunday school excursions and picnics.

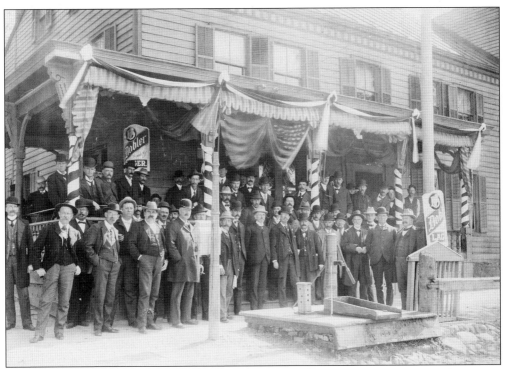

Pres. Theodore Roosevelt visits the Dearstyne Hotel (now known as the Clark Dearstyne Miller Inn) during the early part of the 20th century. The inn, built about 1790, is located on Forbes Avenue (previously known as Mineral Street). Most recently, it was known as the Harbor City Tavern. It is now in very poor condition. The building is listed in the National Register of Historic Places.

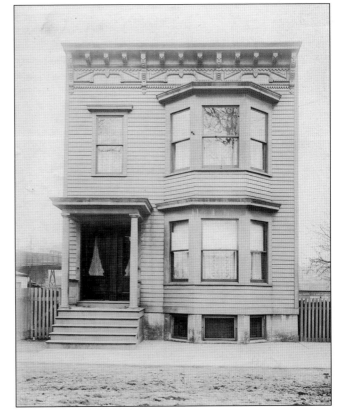

Peter Murphy's house, located at 15 Herrick Street near Washington Street, is shown here. The house was located near what is now the bridge to the Amtrak station. Murphy was a switchman for the United Traction Company. The photograph dates to about 1910. (Courtesy of Ernie Mann.)

This is a view of Washington Avenue looking southwest at Eighth Street. This photograph is from about 1920. (Courtesy of the Troy Public Library.)

A c. 1920 photograph of Ninth Street is presented here. This is north from Birch Street. In 1920, most of these houses would have been relatively new. (Courtesy of Ernie Mann.)

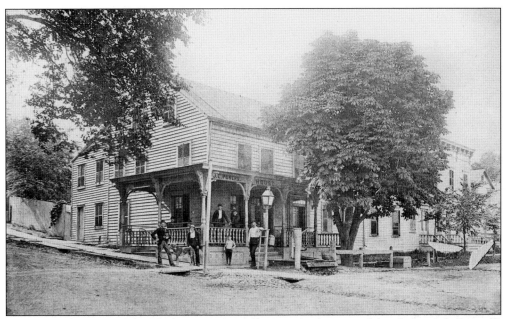

Here is another view of the Clark Dearstyne Miller Inn. At the time of the photograph, James E. Powers operated the inn. Powers operated the hotel from 1891 to 1902. Notice the wooden water pump in front that dispensed mineral water.

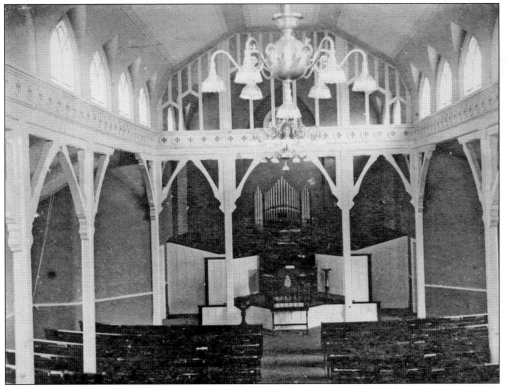

Here is an interior view of First Congregational Church. This photograph would date to about 1890.

Here, one finds another view of the interior of First Congregational Church. This photograph appears to be later than the one on page 53, probably about 1920.

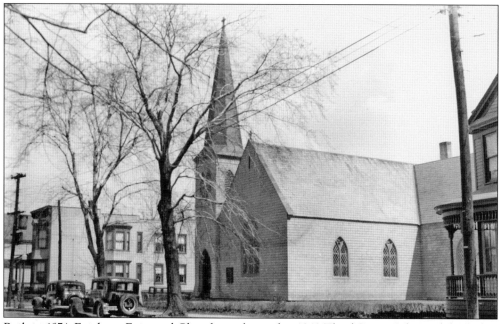

Built in 1874, Epiphany Episcopal Church was located at 1249 Third Street. It burned down, but its records have survived. After the church burned, the congregation joined with the Messiah Episcopal Church. The new church, called the Church of the Redeemer, was built across the street in 1963. This photograph dates to about 1930.

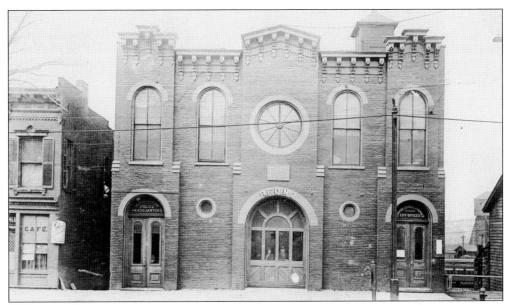

This is an image of the old city hall, fire station, and police department built in 1870 that was located at 959 Broadway. It contained the G.S. Mink Steamer and T. Claxton Hose Company No. 2 fire departments. The building was demolished in 1950. The new fire station was built next door in 1951. (Courtesy of Jack Schumaker.).

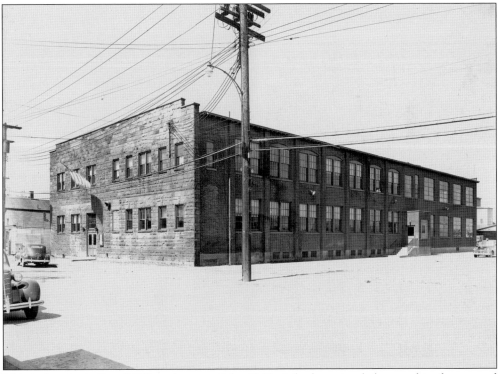

This is the city hall at 505 Broadway as of the 1940s. It had previously been a shirt factory and before that a movie theater combined with a bowling alley. The Zappala Block Company now owns it.

The Knights of Pythias, Riverside Lodge No. 47, held meetings at the Pythian hall at 1561 First Street.

This house is located at 1417 First Street. At the time of the c. 1890 photograph, the house would have been located within the village of Bath-on-the-Hudson, and its address would have been 35 Watson Street. It is interesting to note the unpaved street and wooden sidewalks. Bath-on-the-Hudson was annexed to the city of Rensselaer on January 1, 1902. (Courtesy of Cathy Ody.)

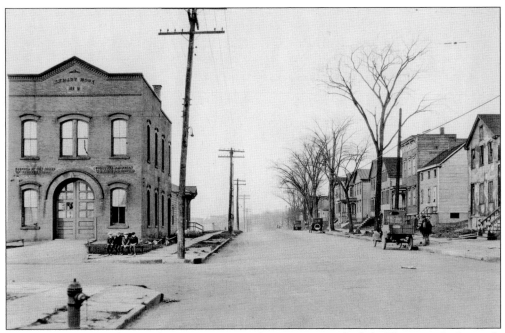

East Street is pictured around 1920. Hart Hose Company is on the left. The street looks much the same today. (Courtesy of the Troy Public Library.)

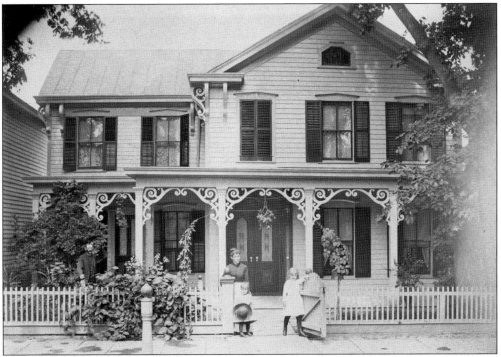

This house was located at 1423 Broadway. This photograph was taken about 1885. Pictured here are Samuel Blackburn, an engineer on the New York Central Railroad; Katherine and Mabel ?; and their aunt Mary ?. W.E. Morrill of East Albany was the photographer. (Courtesy of William and Joan Senter.)

Casper Pruyn was the agent for William Patterson Van Rensselaer, director of the eastern part of Rensselaerswyck. This is his house, built in 1838 on what is now called Forbes Avenue (previously Mineral Street). The house is listed in the National Register of Historic Places. Next door is the office from the same date. This is where the farmers would bring rent payments.

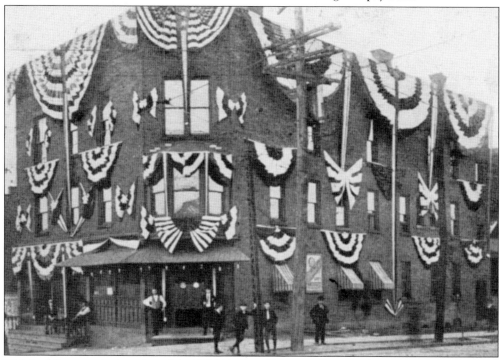

This building was the location of the 1906 Hudson Volunteer Firemen Association. This was the Jonathan Nuttall Saloon, Kapps hall, and G.A.R. hall and was located at 800 Broadway. Later, the top two floors were removed and it became the Roxy Dry Cleaners.

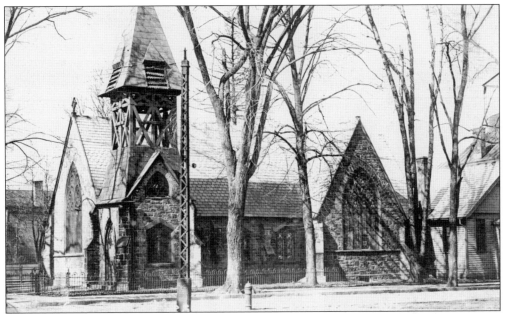

The Church of the Messiah, an Episcopal church, was located at the bottom of Third Avenue near Broadway. It was built in 1854. In 1971, the structure became the Rensselaer Girls Club, and it was torn down in 1991.

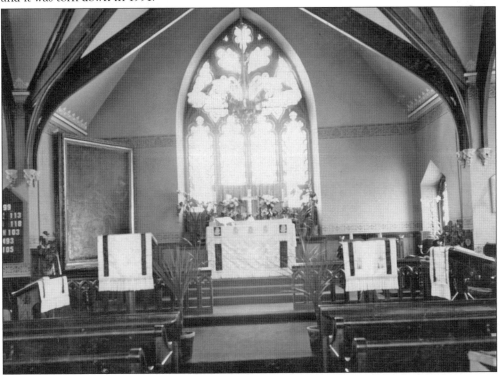

Here is an interior view of the Church of the Messiah. The painting, *The Descent from the Cross*, was a copy ordered by Paul Forbes and given to the church. (Courtesy of Rensselaer City History Research Center, gift of Mary Dunham.)

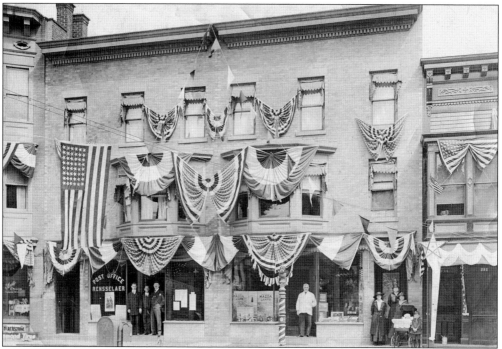

The Rensselaer Post Office was located at 240 Broadway from 1914 to 1936. Before 1914, this building had been a frame shop. Next door was the barbershop and variety store of J.W. Wickens. Both buildings still exist.

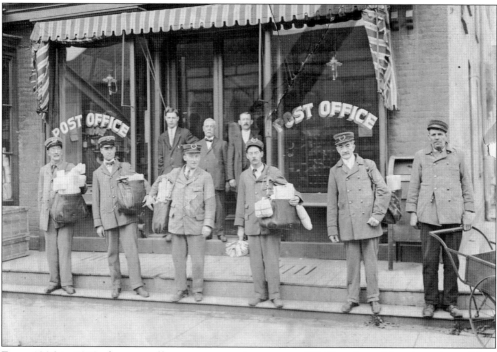

From 1906 to 1913, the post office was across the street at 229 Broadway. Here is a view of that post office.

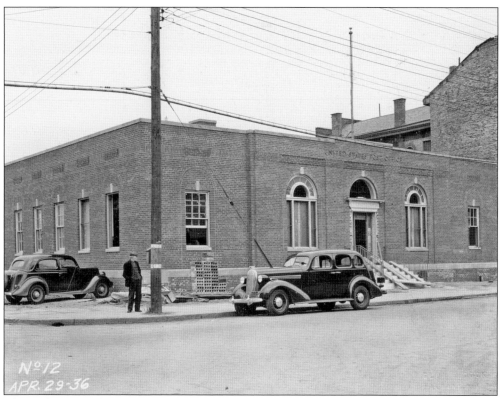

This is the post office that was built in 1936. It was located at 201 Broadway. This had been the site of the Rensselaer House hotel. Notice that in the photograph, it is still under construction. It is now the Rensselaer City Police Department. (Courtesy of Jack Schumaker.)

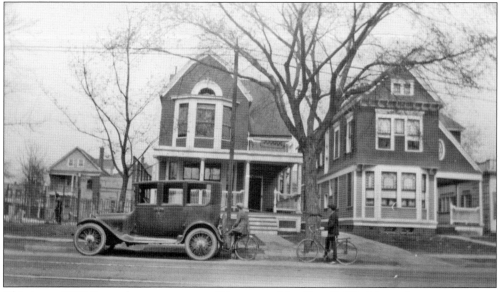

This is a c. 1920 Rensselaer street scene. (Courtesy of the Troy Public Library.)

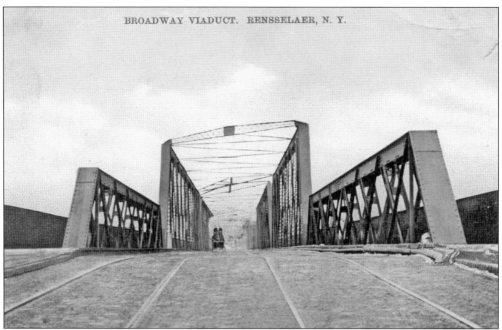

The viaduct bridge, built at the end of the 19th century, that takes Broadway over the railroad tracks is shown here. One can see the double trolley tracks.

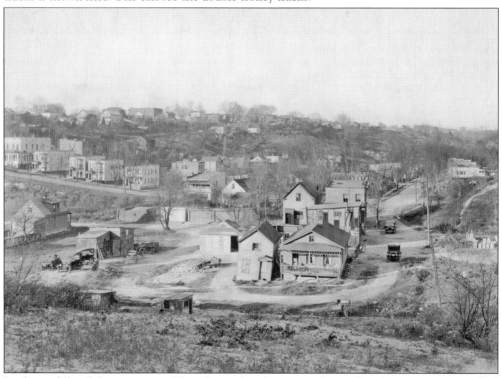

In the middle of the city, east of Broadway, the elevation is lower. For this reason, it is called the Hollow. To the left is Partition Street. This view is from about 1920. (Courtesy Troy Public Library.)

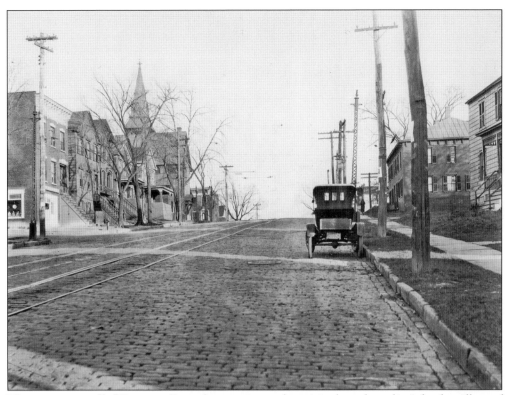

This street was called Partition Street because it was the original northern limit for the village of Greenbush. Looking east, the steeple of the First Congregational Church is on the left. (Courtesy of the Troy Public Library.)

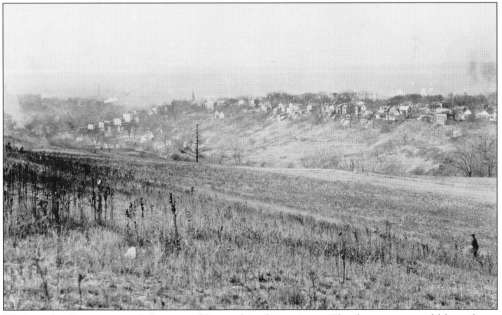

This is a bird's-eye view of the city of Rensselaer facing west. The front part would have been located in the town of North Greenbush. (Courtesy of the Troy Public Library.)

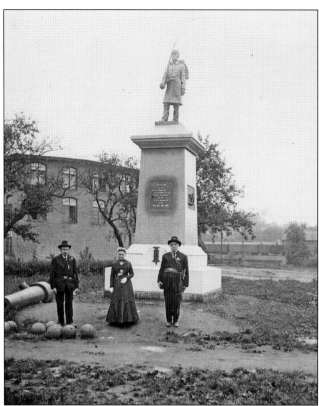

The Soldiers and Sailors Monument is located at the corner of Washington Street and Third Avenue. It was dedicated in 1910. It appears that this photograph was taken as the finishing touches were being added. The photograph was taken by John Wickens. (Courtesy of Ernie Mann.)

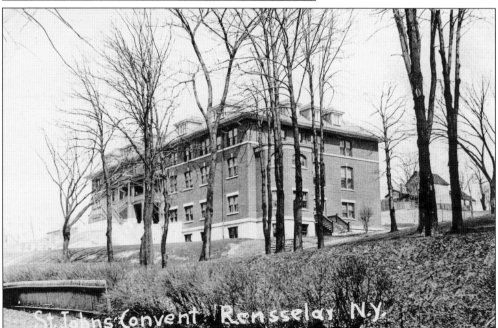

Here is the Mount St. John's Home. The orphanage, built in 1914, was run by the Sisters of Mercy until it closed in 1957. It was especially known for its band. It should be noted that the inscription on the photograph is incorrect; the convent was next door.

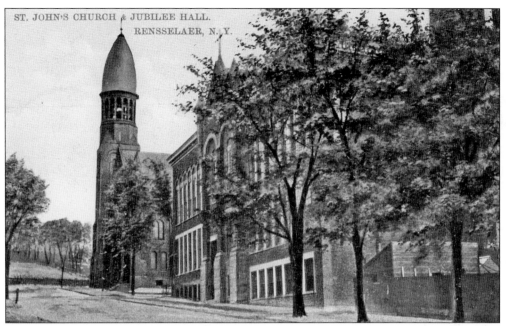

St. John's Church and School is now the Parish of St. John the Evangelist and St. Joseph. The church was rebuilt 1893 after being destroyed by fire in 1890. The school building, the Golden Jubilee Hall, was built in 1903.

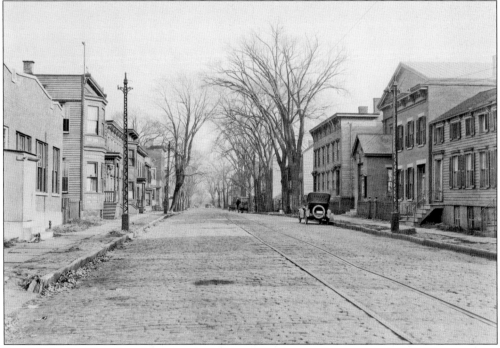

First Methodist Church is shown on the right on Washington Street around 1920. The structure, constructed in 1853, is the oldest church building in the city. On the left is the building used by the Ashe Manufacturing Company to make knitted clothing. (Courtesy of the Troy Public Library.)

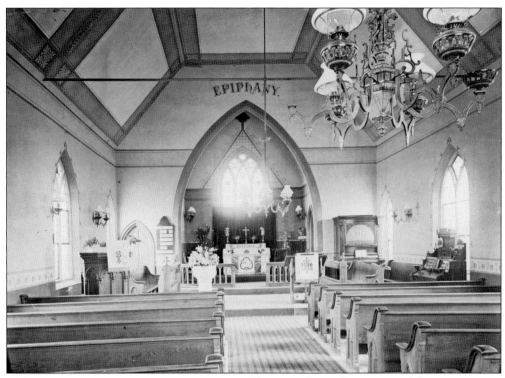

This view shows the interior of the Church of the Epiphany, which was located on Third Street. The photograph would date from about 1900.

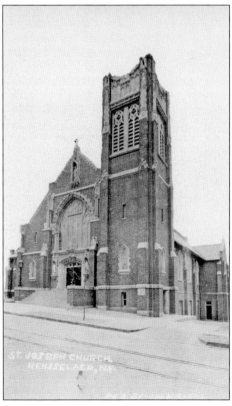

St. Joseph's Roman Catholic Church, built in 1917, is located at 950 Third Street and is now the Rensselaer Open Bible Baptist Church. The photograph on page 45 shows the church when it was being constructed.

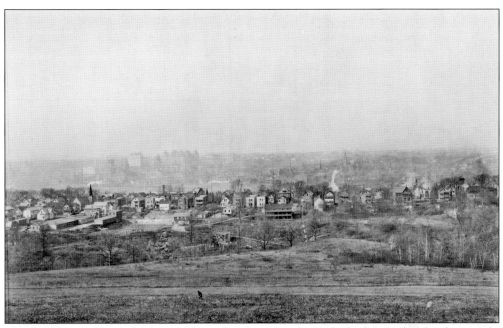

Illustrated here is a view of the city of Rensselaer from the east. In the background of the photograph, the city of Albany and the state capitol can be seen. (Courtesy of the Troy Public Library.)

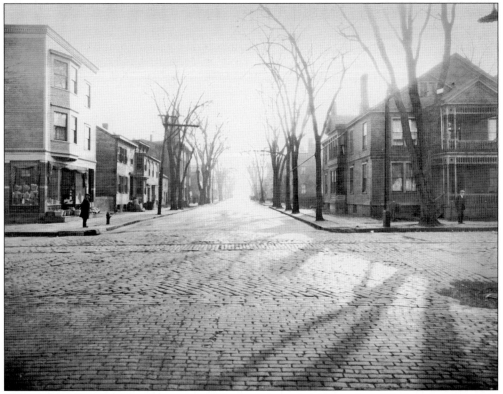

The view in this c. 1920 photograph of Second Avenue looking from Washington Street in Rensselaer shows Guilfoil's Grocery Store on the left. (Courtesy of the Troy Public Library.)

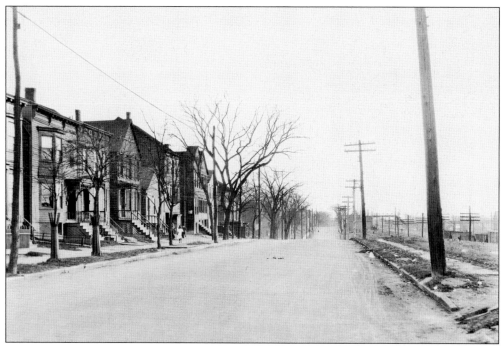

Here is a view of East Street about 1920. Railroad tracks can be seen on the right. The houses have not changed much today. (Courtesy of the Troy Public Library.)

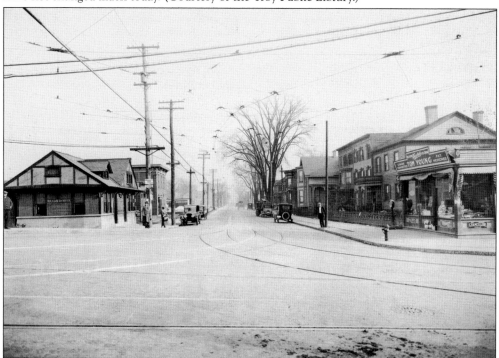

Here is a photograph looking north of the intersection of Broadway and Third Avenue. Tom Young's Drug Store is on the right. The trolley transfer station is on the left. This station can be seen during a flood on page 23. (Courtesy of the Troy Public Library.)

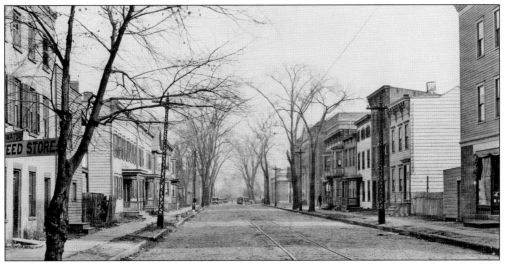

Washington Street is shown here. W.S. and P.S. Staats Flour, Feed, and Grain Store, seen on the right, was located at 19 Second Avenue. Previously, the building was Fred Carr, Steam Cracker and Biscuit Manufactory, as seen on page 109. (Courtesy of the Troy Public Library.)

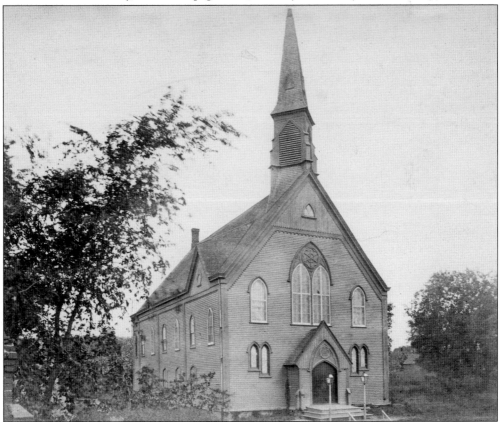

First Baptist Church was located at First and Church Streets. The congregation was organized in 1866. The church building was dedicated in 1875, and it burned down on March 20, 1951. A new church was built on Washington Avenue. (Courtesy of Ernie Mann.)

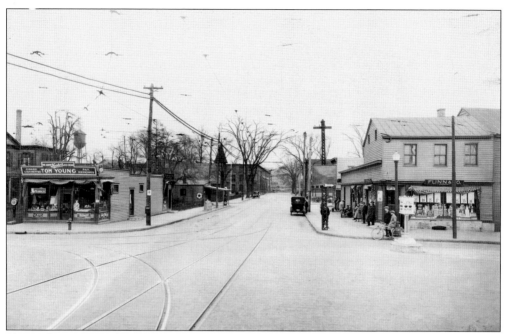

Shown here is Broadway at Third Avenue about 1920. Tom Young's Drug Store was at 300 Broadway, and Flinn and Co. was at 280 Broadway. Flinn and Co. was a meat market and grocery store. Tom Young's Drug Store was removed in 1932 to make room for the ramp to the bridge. (Courtesy of the Troy Public Library.)

Columbia Street and Broadway appear in this c. 1920 image. (Courtesy of the Troy Public Library.)

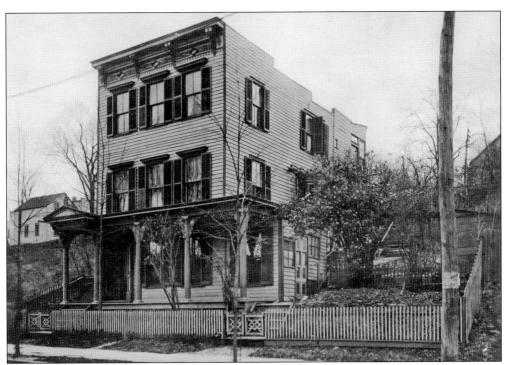

The Charles A. Thatcher House is located at 1244 Broadway. Thatcher was a soldier in the Civil War. During the war, he was wounded and was interned at Libby Prison. He was a carpenter and built this house himself when he moved to Rensselaer. The photograph is dated 1908, and the house is still standing.

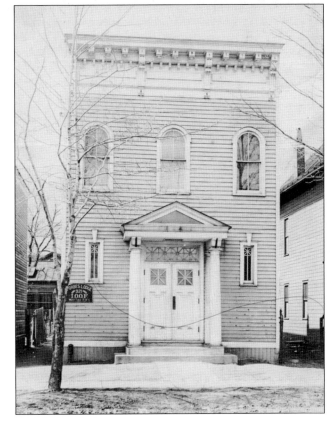

This is the lodge house for the Forbes Lodge of the Odd Fellows, which was located at 1567 Fifth Street in Bath-on-the-Hudson.

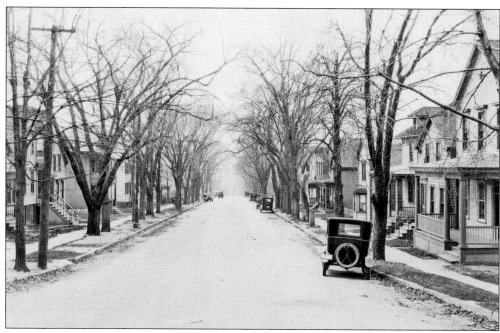

Here is a view of Third Avenue looking west from High Street. Note that the Third Avenue viaduct bridge has not yet been constructed. The photograph is from about 1920. (Courtesy of the Troy Public Library.)

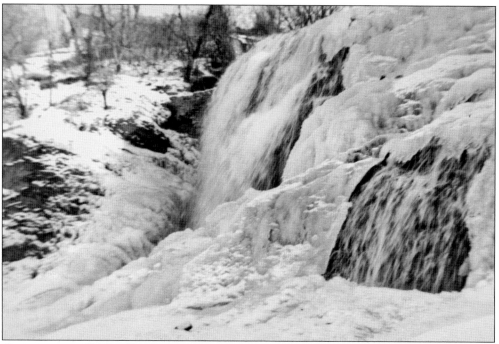

Here is a view of Mill Falls taken in the 1950s. The falls are also called Red Mill Falls. They are on Mill Creek, which was called De Laet's Creek, or Tierckenkill previously. The creek is the location of what is possibly the oldest industrial site in the 13 colonies. The falls are now on private property.

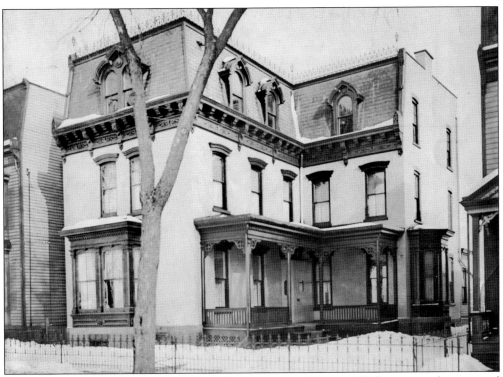

This is the George Wallace House, located at 118 Second Avenue. Wallace was a designer and assistant superintendent at Huyck Mills.

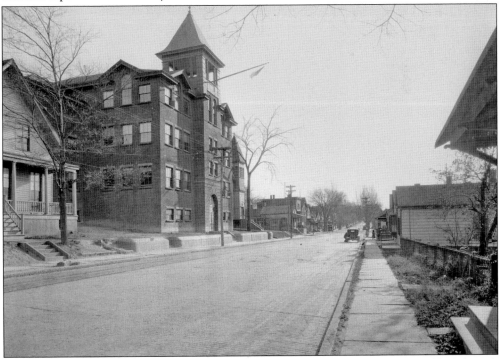

Here is a view of Broadway and School No. 3 on the left. (Courtesy of the Troy Public Library.)

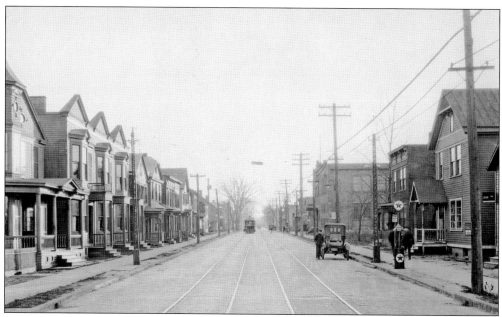

Here, the view looks south on Broadway from the viaduct bridge. The former Columbia Hall and city hall is on the right. Notice the two sets of trolley tracks. (Courtesy of the Troy Public Library.)

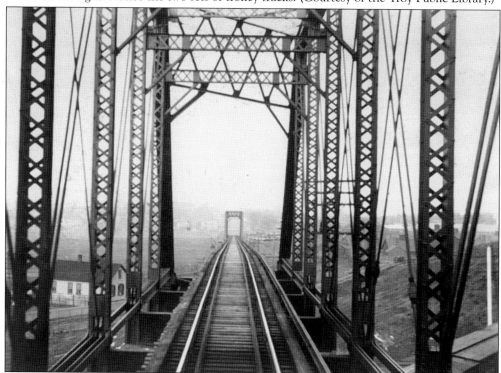

This is the bridge for the Albany Southern Railroad near Columbia Street, which is on the right. This view is looking west as the Albany Southern tracks traverse the tracks of the Boston and Albany and the New York Central railroads. The Hudson River can be seen in the back. (Courtesy of the New York State Library.)

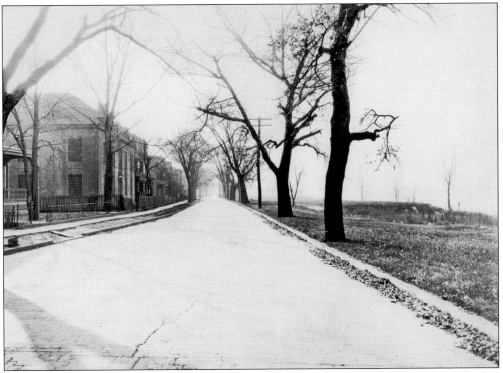

Riverside Avenue is shown here. Fort Crailo can be seen on the left before it was remodeled in the mid-1920s. (Courtesy of the Troy Public Library.)

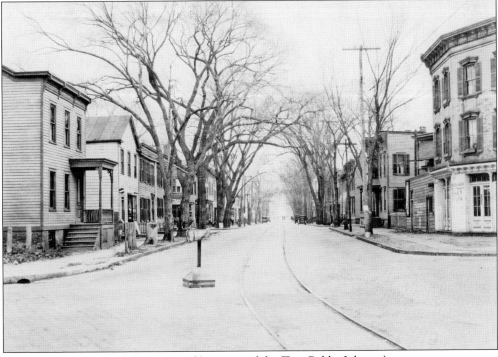

Third Street is pictured about 1920. (Courtesy of the Troy Public Library.)

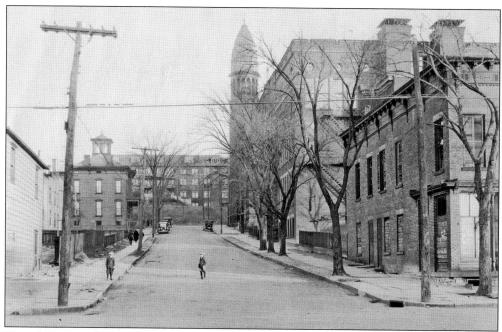

Herrick Street is shown here about 1920. St. John's Church is on the right. In the back, St. John's Convent can be seen. The rectory for St. John's is on the left. The cupola on the rectory is now gone. (Courtesy of the Troy Public Library.)

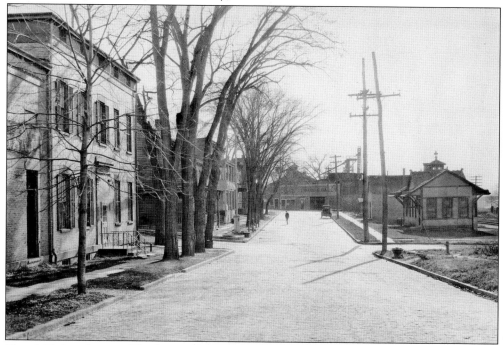

Here is Forbes Avenue. The house of patroon agent Casper Pruyn is on the left. On the right is the train station for the New York Central & Hudson River Railroad, formerly the Troy & Greenbush Railroad. This was the only station between Greenbush and Troy. (Courtesy of the Troy Public Library.)

This was one of the houses own by the Gavin family and was called the Brown House. It was located on Munger Avenue. The Gavin family ran a farm nearby within the city limits. They raised mainly chickens and some pigs. (Courtesy John Gavin.)

This view is of the C.G. Ham House, located in Bath-on-the-Hudson. It was located at 42 Forbes Avenue, behind what is now the Doane Stuart School. Charles G. Ham was a partner in Ham and Cook, a coal business on Broadway. He was trustee of the village of Bath-on the-Hudson in 1877. The house was destroyed by fire on April 5, 1943, with an estimated loss of $15,000. This is from the 1876 *County Atlas of Rensselaer, N.Y.*

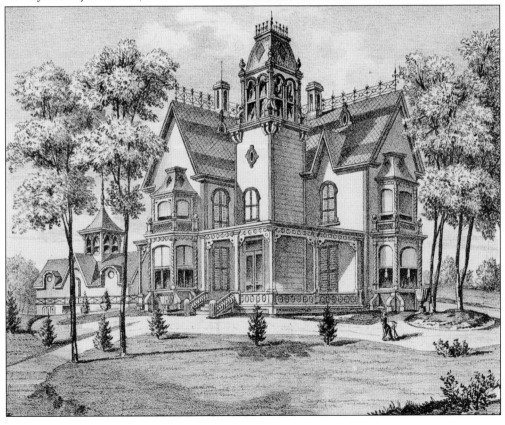

Here is the house of William T. Stubbing on Grove Street. The photograph dates to about 1946. (Courtesy William E. Flanigan Jr.)

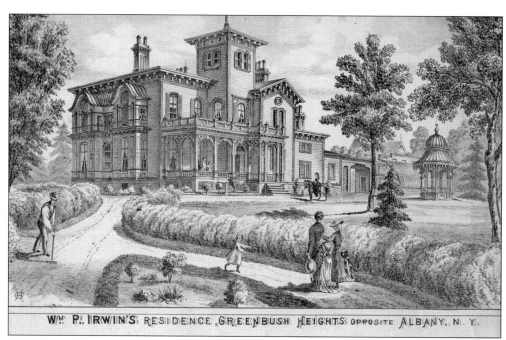

WM P. IRWIN'S RESIDENCE, GREENBUSH HEIGHTS OPPOSITE ALBANY, N. Y.

This illustration is from Beers's 1876 *County Atlas of Rensselaer, N.Y.* The mill owner and banker William P. Irwin had an impressive estate on what is now upper Aiken Avenue. This part of East Greenbush was annexed to the city in 1902.

A gathering is pictured at the corner of Broadway and Third Avenue. (Courtesy of Ernie Mann.)

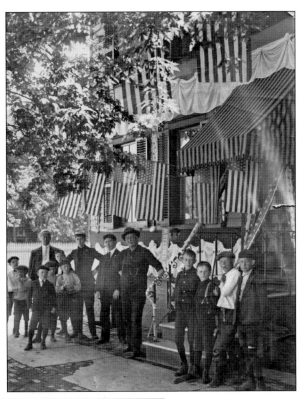

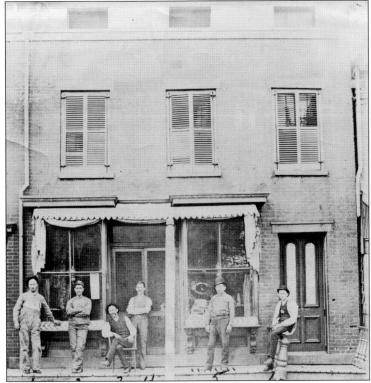

Charles Farren is standing in the doorway of his barbershop at 100 Broadway in a photograph taken about 1880. Farren died on March 1, 1889. (Courtesy of Ernie Mann.)

Here is the William Aiken House. It was built in 1818 and is considered the home of the founder of the city. There is a tradition that General Lafayette, Edmund Charles Genet, and William Akin had a meeting in the house in 1824. (Photograph by the author.)

The Irwin Bank, at the corner of Broadway and Second Avenue, is shown here as illustrated in the 1876 *County Atlas of Rensselaer, N.Y.* Later, it was the State Bank of Rensselaer. Many people remember the building as J. Max Hackel's jewelry store. It is now listed in the National Register of Historic Places.

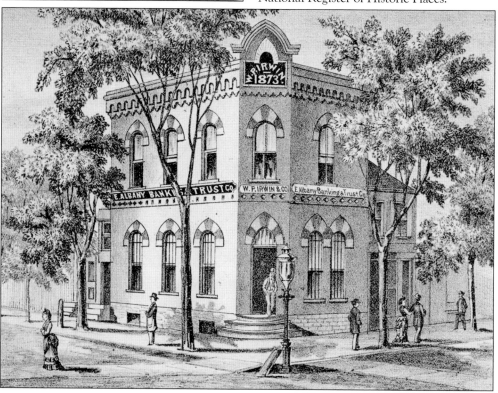

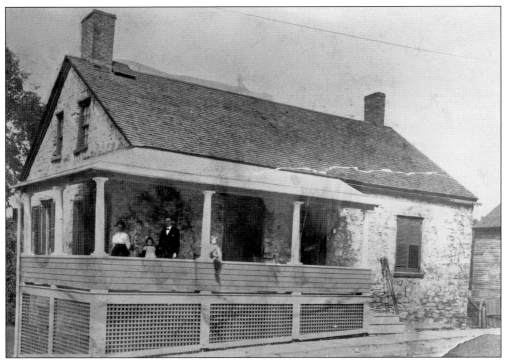

The second-oldest house in the city is Wood's House, probably built about 1743. It was at one time a pottery, a tannery, and a boys club. John W. Wood (or Woods) lived in the house from about 1790 to 1830. The home is also known as the Philip Carner House, and it appears that Carner was a potter by the 1760s. It is now a private residence.

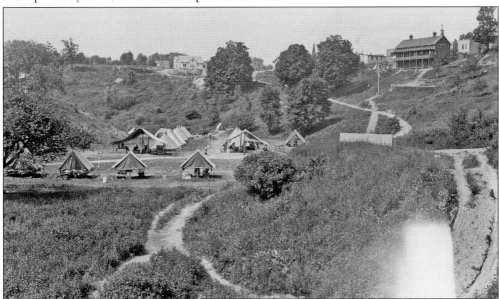

The rifle range is shown here during a Girl Scout encampment. The Rensselaerswyck Rifle Range was located east of the northern part of Third Street. It was established in 1880 as a practice area for the National Guard. On the hill, one can see the barracks that burned in 1936. The superintendent lived at 1422 Third Street. (Courtesy of Ernie Mann.)

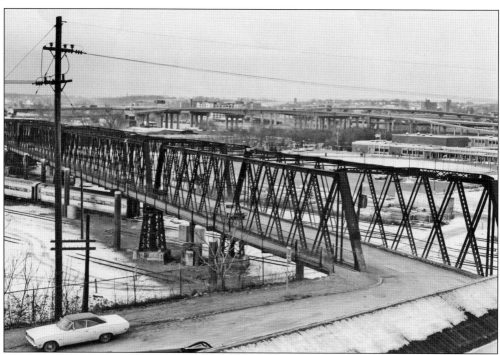

Here is a view of the viaduct bridge that carried Broadway over the railroad tracks. This view appears to date from the 1960s.

This shows Third Street looking from McNaughton Avenue. This image is from about 1920. (Courtesy of the Troy Public Library.)

Five

THE ROUNDHOUSE

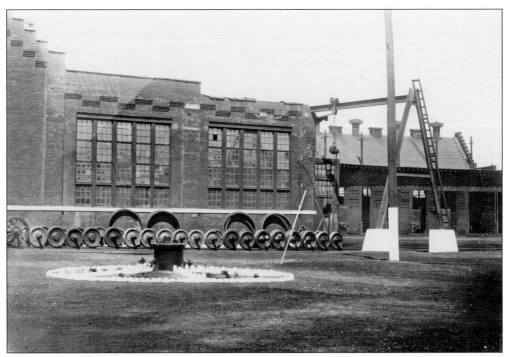

The New York Central had a major roundhouse in Rensselaer. After the publication of the fine book on Rensselaer railroads by Ernie Mann, the following photographs were discovered and donated to the Rensselaer City History Research Center. All of the photographs date from before 1943.

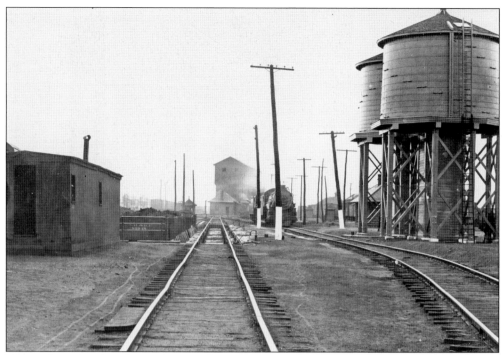

Here is the railroad yard near the roundhouse. Auxiliary buildings included a blacksmith's shop, office, and storerooms.

Shown here is an exterior view of the roundhouse. Also known as the engine house, it was built in 1902. The outer radius of the building was 208 feet.

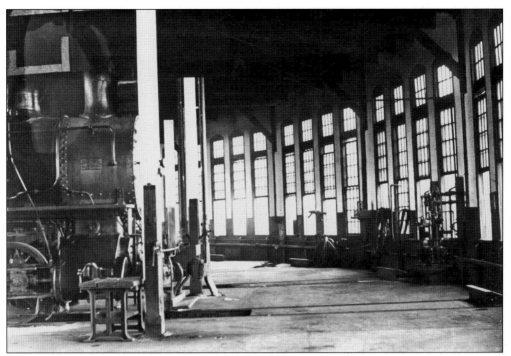

This is an interior view showing a steam engine on the left. In the original 1902 plans, there were 30 stalls, with provisions to extend the number to 60.

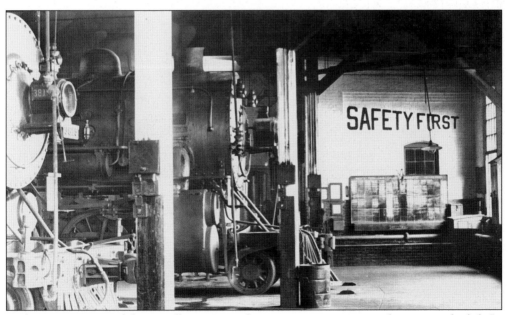

In this interior view of the roundhouse, note that two steam engines can be seen on the left. In 1903, between 110 and 140 engines were serviced per day.

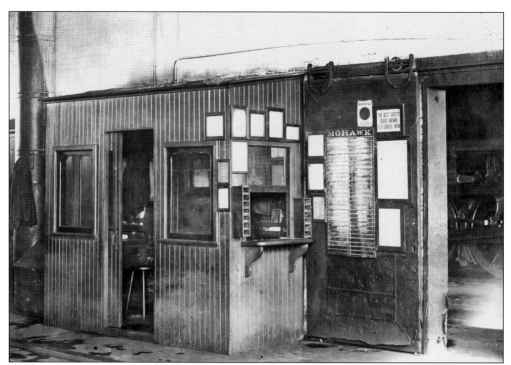

The foreman's office is included in this image. The turntable used to position the engines was designed to carry 200 tons when it was installed in 1902.

The exterior of the New York Central Railroad roundhouse is the focus of this image. The building was located at the northern end of Van Rensselaer Island, which had also been called the Boston & Albany Island. In 1903, the channel was filled in, and it ceased to be an island.

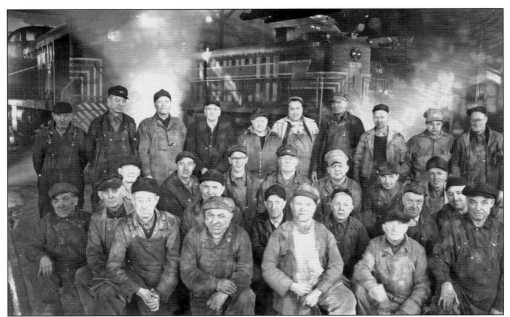

Roundhouse workers pose for this photograph. A diesel engine can be seen in the rear, helping to date the photograph to the early 1940s.

The exterior of the building is shown here. After 1925, the roundhouse was less busy, because freight trains had been diverted to the rails yards in Selkirk, which is south of the city of Albany.

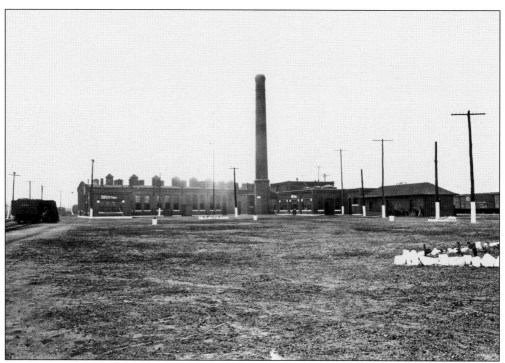

An exterior view of the roundhouse from some distance is shown here. The brick walls were 12 inches think. The roundhouse was demolished in 1955, and the nearby coal facility in 1969.

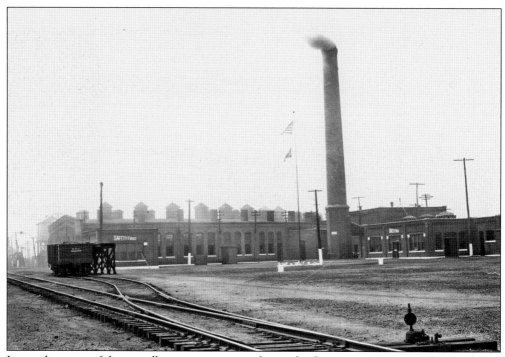

In another view of the roundhouse, one can see the tracks that were use to move the engines to inside the building. The building was designed with an innovating heating system.

The building's exterior is shown in this photograph. The official designation of the building was the New York Central Engine House.

Shown in this photograph are some structures ancillary to the roundhouse.

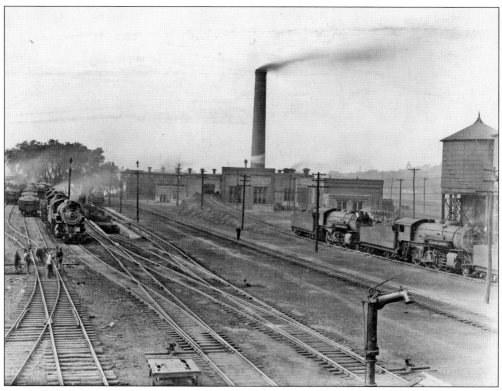

The rail yard is in this photograph, with the roundhouse in the background.

The wood chute next to the roundhouse is in the center of the image.

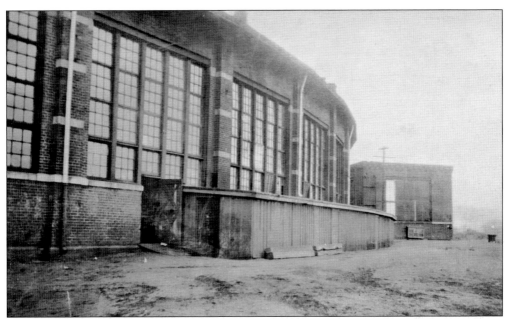

This shows another view of the exterior of the roundhouse, which was built in 1902 and torn down in 1955.

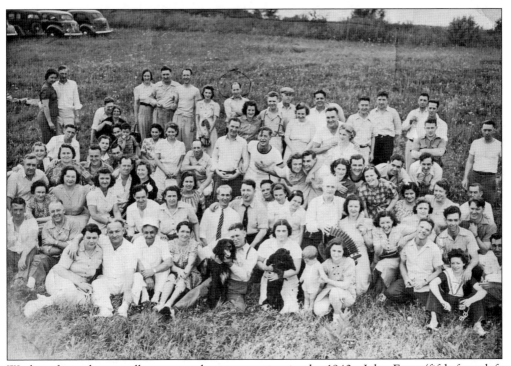

Workers from the roundhouse partake in an outing in the 1940s. John Ferra (fifth from left in back row) poses in the middle of the back row. It is from his family that these photographs were received.

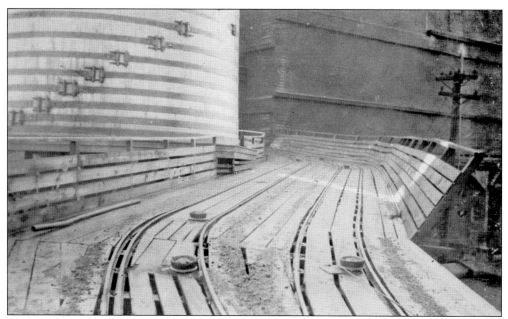

The inside track of the roundhouse is visible here. The inside radius of the building was 130 feet.

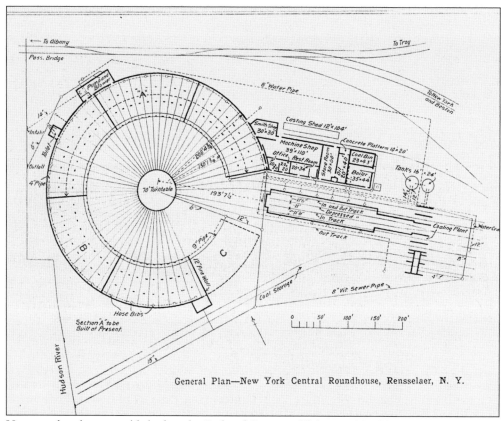

General Plan—New York Central Roundhouse, Rensselaer, N. Y.

Here are the plans as published in the *Railroad Gazette* of February 20, 1903.

Six

BUSINESSES AND INDUSTRIES

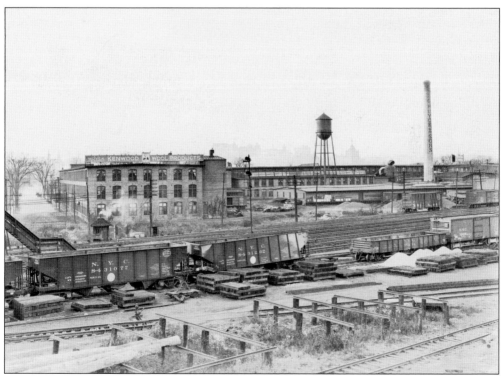

Shown here is the Kenwood Mills of the F.C. Huyck and Sons Company. This view is looking west towards Albany. It was called Kenwood Mills because the first mill was located in Kenwood, near Albany. The company made felts, sleeping bags, coverlets, tweed, and blankets. (Courtesy of Ernie Mann.)

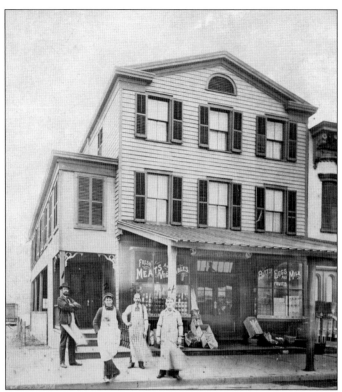

This is a view of the Melius and Hemstreet grocery store, which was located at 53 Broadway. The photograph is dated 1899. Appearing in the photograph are, from left to right, Eugene Hemstreet, Charles Mack, Charles Root, and John Howard. Charles Melius, besides being a partner in the store, was a city judge, railroad engineer, and at one time deputy grand master of the Masons in New York State.

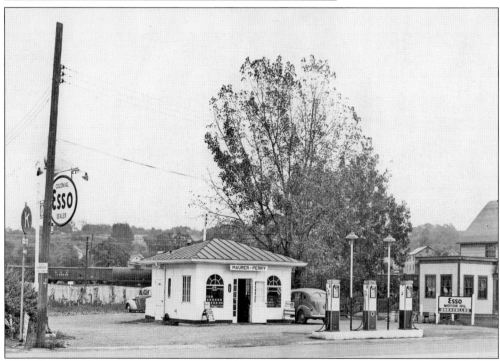

The Maurer Perry Esso filling station was located on Columbia Street. This photograph was taken on October 30, 1939. Previously, the business was called the Colonial Beacon Oil Company.

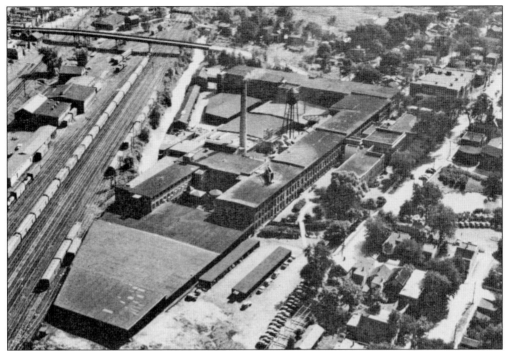

In aerial view looking south, the F.C. Huyck and Sons complex is shown. The bridge is the viaduct carrying Third Avenue over the railroad tracks; at upper right is the roof of Fort Crailo School. Many of the buildings are gone, but some have been transmuted into New York State offices. (Courtesy of the Troy Public Library.)

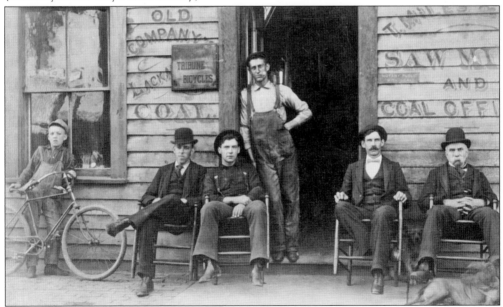

This 1890 view shows the Miles Coal office and sawmill. In front of the office are Dick Strohmaier with a bicycle, Andy Parmerton, Jack Selley, Bill French, and Clarence Herrington. The location was at 273 Broadway, near Third Avenue. The owner was James I. Miles. (Courtesy of Ernie Mann.)

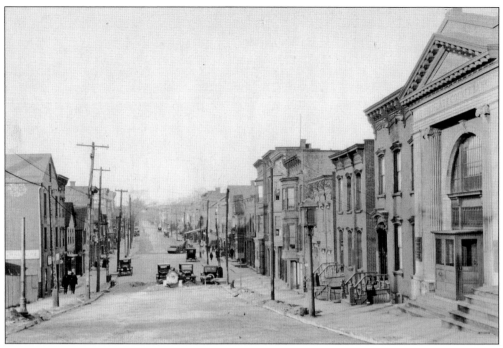

Broadway is seen in this view looking north. The bank building pictured was constructed in 1909 at 810 Broadway. In 1910, it had assets of about $500,000. Later, it became the Rensselaer Public Library; it is now privately owned. The building at left in front was the Railroad YMCA and the Boston & Albany Men's Association Hall. Note that the street is being repaired in the middle.

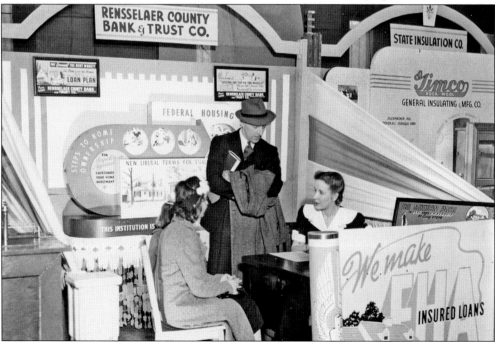

The Rensselaer County Bank and Trust Company, pictured some time during the mid-1940s, has set up a booth at a local event.

This is a view of the Munger Bank building located at 855 Broadway. Later, it became the Rensselaer County Bank. The Munger Bank was owned by John F. Munger, after whom Munger Street is named. It is interesting to note that Munger also sold real estate and insurance.

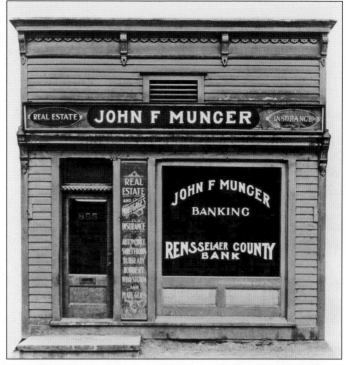

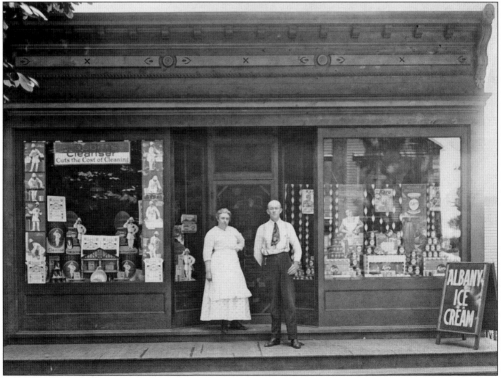

James Pickin had a grocery store at 63 Second Avenue. Pickin resided at the same location. This photograph was taken in 1919. (Courtesy of Ernie Mann.)

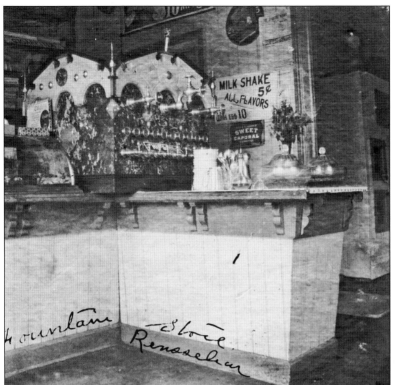

Here is an interior view of the Goewey store, which was located at the corner of Fourth and Glen Streets. It shows the store in about 1910. (Courtesy of Sharon Zankel.)

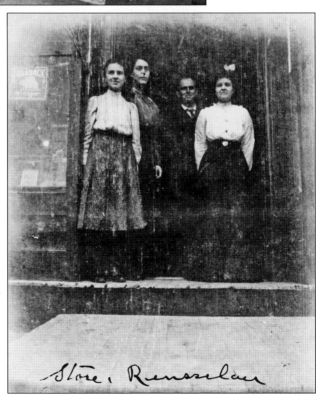

This is an exterior view of the Goewey store. (Courtesy of Sharon Zankel.)

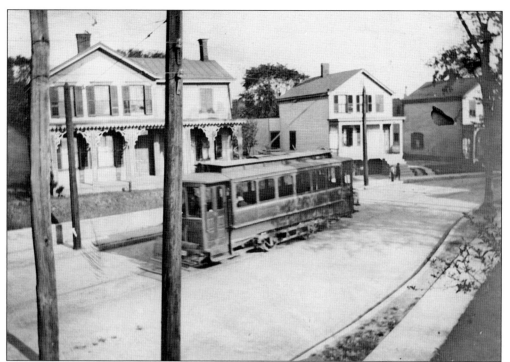

This 1910 photograph of a United Traction Company trolley was taken from the roof of 1307 Third Street, which was the residence of Harriet "Hattie" Goewey. (Courtesy of Sharon Zankel.)

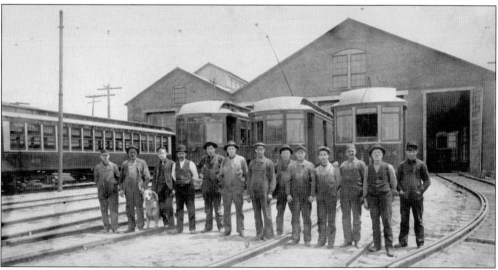

This photograph shows the Albany Hudson Fast Line, which in 1909 became the Albany Southern Railroad. It was a third rail line that provided service between Albany and Hudson. It had its main offices and trolley shops in Rensselaer, on Aiken Avenue near Columbia Street, and operated from 1899 to 1929. The company also sold electricity, for which there is a bill from 1913 in which four kilowatts of electricity were sold for $1.42—which is much more than most people pay per kilowatt hour today. None of the men are identified. (Courtesy Rensselaer City History Research Center, previously in the collections of Kevin Franklin, Charles Franklin, and George Weilland of Albany.)

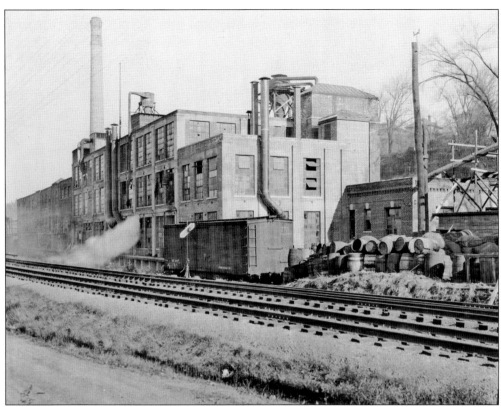

Although it had a major fire (see page 35), Barnet Mills continued in business for many years. This photograph dates from the 1920s. (Courtesy of the Troy Public Library.)

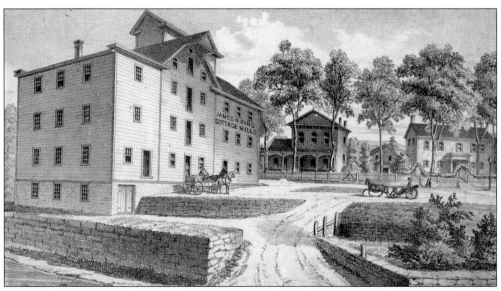

The James N. Ring Mills are illustrated in this lithograph from the 1876 *County Atlas of Rensselaer, N.Y.* They milled flour and grain. The houses in the rear still exist on what is now called Ring Street.

The Garvin farm, purchased with money from a World War I bonus, was at the end of Munger Street, within the city limits. This chicken coop was about 100 feet long. The child is Mary Emanuale Gavin, about 9 years old. The lady next to her is Elizabeth "Bess" Robbins, and next to her is Leona Gavin, about 18 years old. Charles Henry Gavin, aged about 45, is in front, and the dog is Pal. This photograph dates from about 1938. (Courtesy of John N. Gavin.)

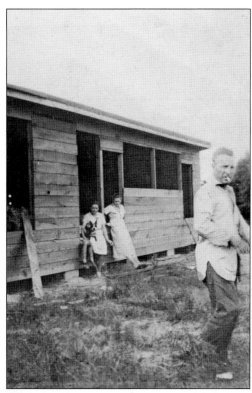

Here is the snowy road to the Gavin farm. (Courtesy of John N. Gavin.)

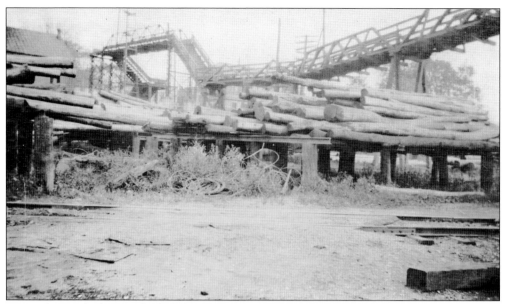

Pictured is a telephone pole skid that was part of the New York Central Railroad facility. The photograph is dated October 2, 1918.

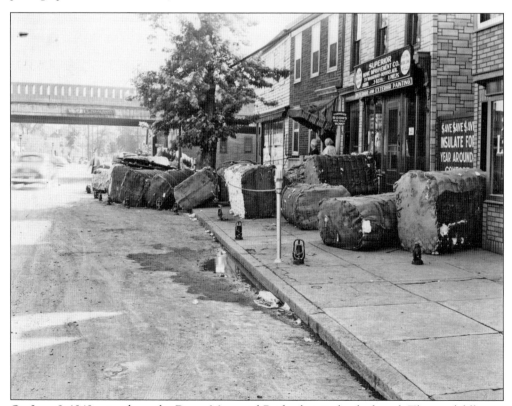

On June 9, 1949, a truck on the Dunn Memorial Bridge lost its load of wool. The wool fell onto Broadway and Third Avenue. The Superior Home Improvement Store, seen in the photograph, was located at 274 Broadway. The photograph is by John A. Heller. (Courtesy of Ernie Mann.)

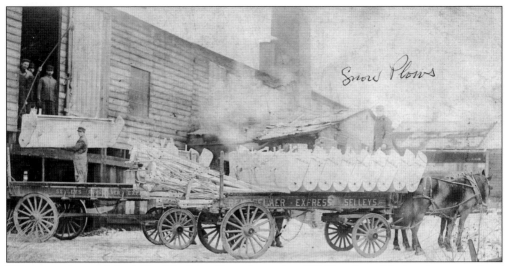

This is an image of the Miles Machine Shop, located at 273 Broadway. Notice that snowplows have been completed and are ready for delivery. Wagons operated by Selley's Rensselaer Express are ready to make the delivery. Somewhere in the 1906 photograph are William French, Al Birch, James Layman, J. LaCoy, and L. Vanderhoel. (Courtesy of Ernie Mann.)

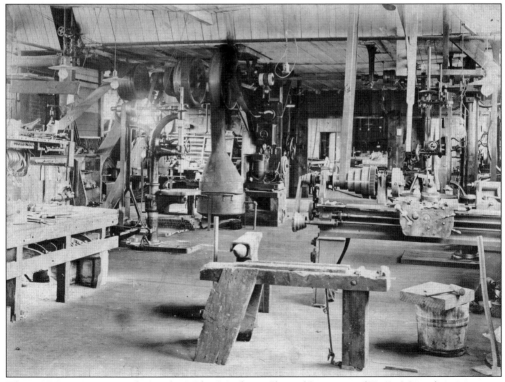

This 1906 interior view shows the Miles Machine Shop. (Courtesy of Ernie Mann.)

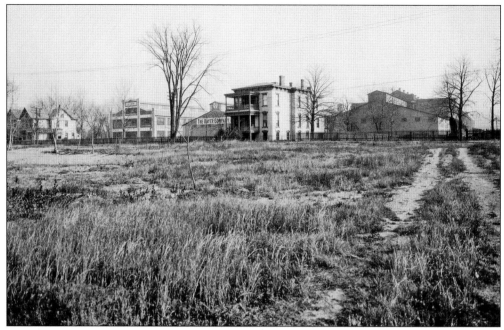

Sterling Winthrop's Bayer factory was a major manufacturer and employer within the city. It was the first facility to make aspirin in the United States and was one of the largest drug manufactures in the country. (Courtesy of Ernie Mann.)

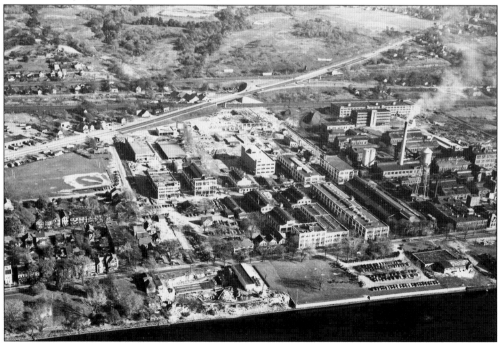

This aerial view shows the Sterling Drug Factory, later known as Winthrop Sterns, a maker of Bayer aspirin. To the right is the factory of General Aniline and Film Company, formerly Hudson River Aniline Color Works. Coyne Field can be seen on the left. The photograph was taken in the 1940s. (Courtesy of the New York State Library.)

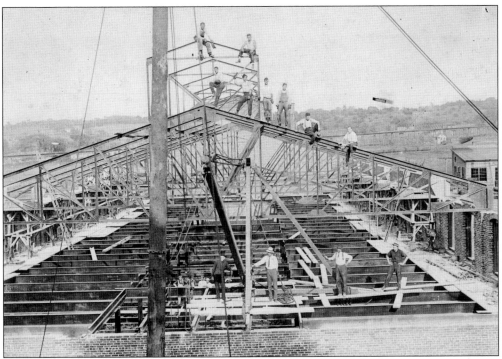

Construction of a new building for the General Aniline and Film factory is shown here. (Courtesy of Ernie Mann.)

This is from an advertisement for the industrial metal Monel in the June 1937 *Fortune* magazine. It shows workers making Bayer aspirin at the Rensselaer plant.

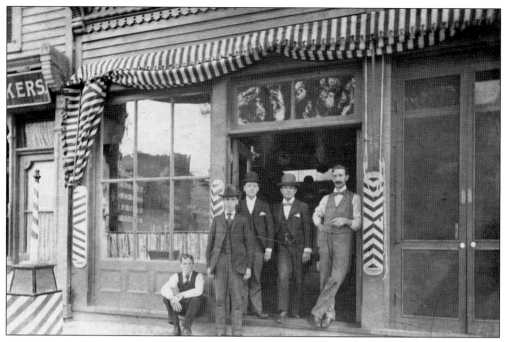

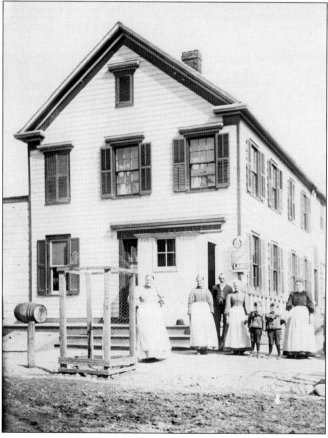

The T.C. Bullent Barber Shop, located at 212 Broadway, is shown in this c. 1900 image. Elmer Bullent, age 18, is seen seated. Next door is the bakery of William J. Allen. Both Bullent and Allen lived in their respective business buildings.

Kapps was a hotel, restaurant, and bar at 1006 Sixth Street in the Hollow. It was run by George K. Kapp. In 1922, it advertised that chicken dinners were a specialty.

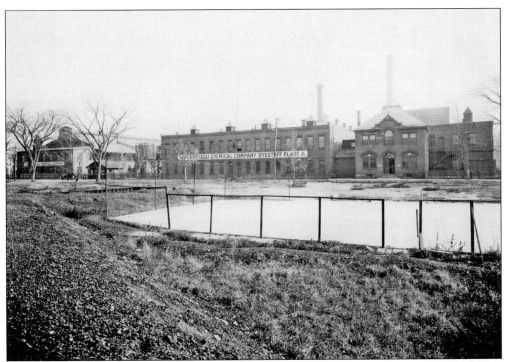

Grasselli Chemical Company was located at 34 Riverside Avenue near the Sterling (Bayer) factory and the General Aniline and Film facilities.

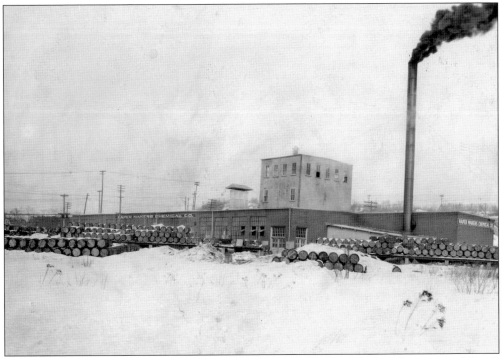

The Paper Makers Chemical Company was located on Columbia Street at the corner of South Street. This photograph dates from the 1940s.

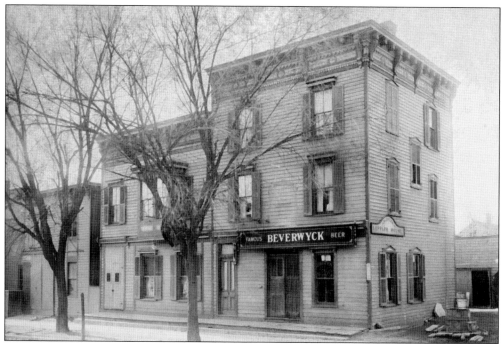

Here is a photograph of Leffler House at 79 Washington Avenue. Andrew M. Leffler owned it from 1894 to 1911. In 1912, it was operated by George Scouten, then in the following year by his widow, Minnie. Later, Benson Scouten was the proprietor until 1934 when it became the Manor Inn. This photograph has the signage "Scouten Ren. Café" in the front window, which would indicate that at the time of the photograph the business was operated by Scouten. It is now Casey's Restaurant, a popular eating establishment. (Courtesy James Casey.)

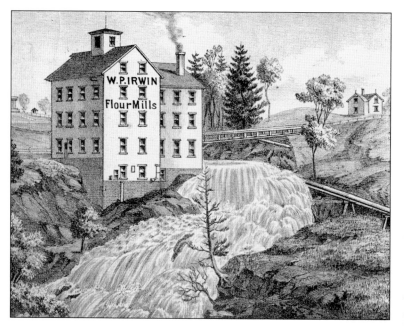

W.P. Irwin Flour Mills was located on the Mill Falls (also known as Red Mill Falls). This image is from the 1876 *County Atlas of Rensselaer, N.Y.* Notice the flume that provided power to the mills at the lower levels. The falls are now privately owned.

Garrison and Lansing was a meat and grocery store located at 87–91 Broadway and 14 Ferry Street. It apparently would peddle its wares throughout the city. This photograph was taken on October 30, 1891. The store was not in business long after this photograph was taken.

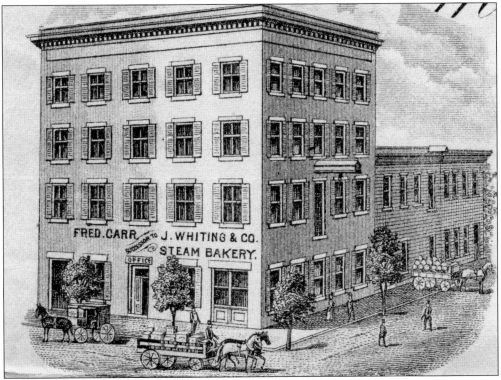

Fred Carr, Steam Cracker and Biscuit Manufactory was located in a building at the corner of Washington Street and Second Avenue. J. Whiting established the business in 1824. It made picnic, soda, and graham crackers and pilot bread, cornbills, alphabets, lemon cakes, jumbees, candy, and other items. Later, it became the W.S. and P.S. Staats Flour, Feed, and Grain Store. The building still exists and now contains apartments. This image is from an 1893 billhead.

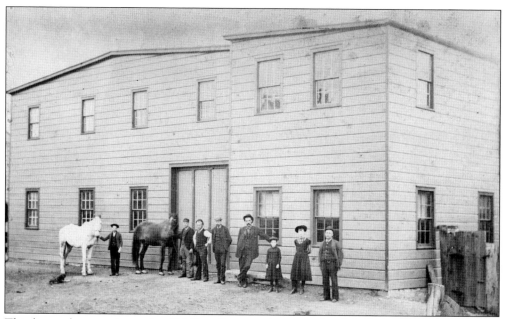

This livery shop was located at 210 East Street and was run by G.S. Wiltse. In this image are, from left to right, John Wiltse, James Wiltse, Walter King, Frank Root, Judge George Stevens, Mattie Wiltse, Cora Wiltse, and George Wiltse. The photograph was taken in 1894. (Courtesy of Ernie Mann.)

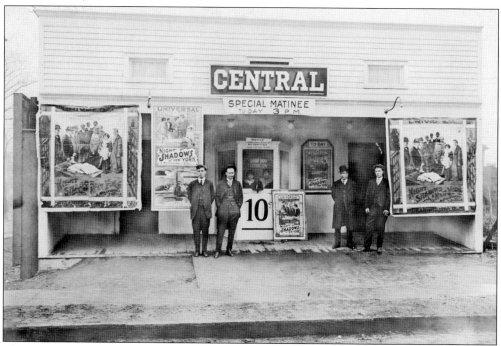

The Central Movie Theatre, also known as Griffith Motion Picture House, was located on Third Avenue near Washington Street. It was later known as the Mack Theater. The movie being shown, *Night Shadows of New York*, was released on May 27, 1913. Pictured, from left to right, are Norman Pratt, Howard Blanchard, and William F. Griffith, the owner. (Courtesy of Ernie Mann.)

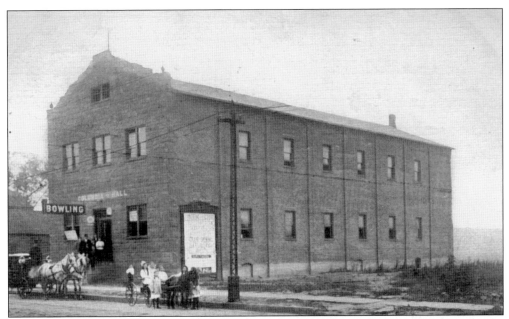

Columbia Hall was on Broadway. It was built as a bowling alley and motion picture theater. After this photograph was taken, it was doubled in size. About 1920, the structure became Bob and Baskind shirt manufacturers. In 1949, it became Rensselaer City Hall. It is now privately owned.

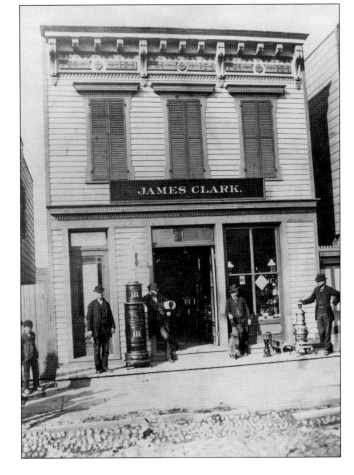

Here is a view of James Clark's store. He was a tin- and coppersmith at 15 Ferry Street in Greenbush. The photograph was taken in 1884. Clark died in 1913. (Courtesy of Ernie Mann.)

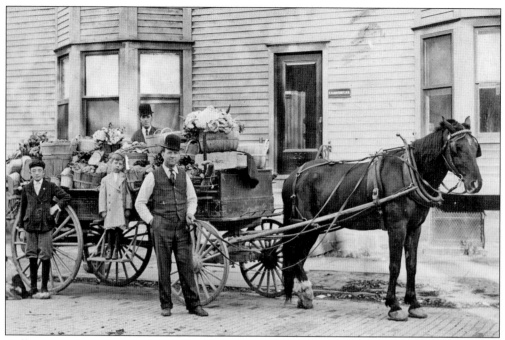

William Sennett, a vegetable vendor, is shown with his cart in front of the office of Elbert H. Humphrey, MD, at 261 Broadway. Sennett's store was actually located at 56 Second Avenue. This photograph dates to about 1905. (Courtesy of Ernie Mann.)

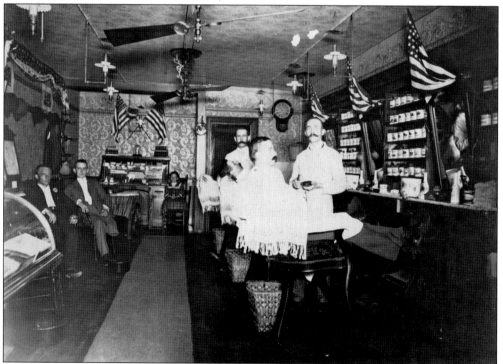

This is the interior of the John W. Wickens barbershop at 238 Broadway. Wickens later became well known as a photographer. (Courtesy of Ernie Mann.)

Seven

PEOPLE

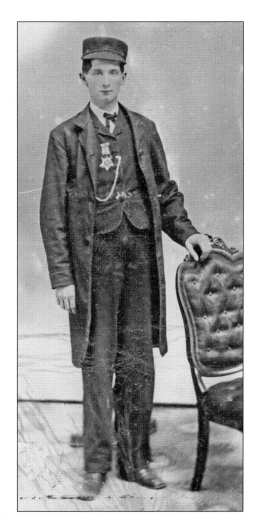

Henry Wilkes (1845–1888) was awarded the Congressional Medal of Honor for heroism during the Civil War. This c. 1866 photograph shows him wearing the medal. He served on US Picket Boat No. 1, and in October 1864, he helped to place a torpedo that exploded the Confederate ram *Albemarle*. He is buried in Beverwyck Cemetery in Rensselaer.

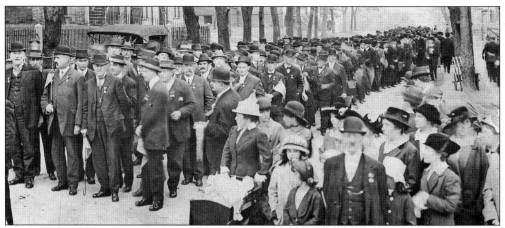

For this Flag Day parade in Rensselaer, the firemen are marching without their uniforms.

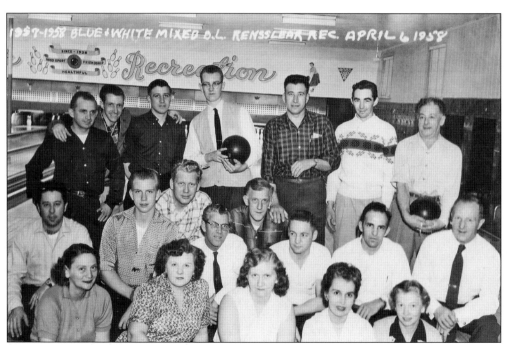

Pictured are participants in a bowling competition on April 5, 1958. This bowling team was organized at the Blue and White Tavern, which was located at 27 Second Avenue. In the photograph, from left to right, are (front row) Florence VanGelder, Dot Chalfont, Ethelyn VanGelder Vooris, Gerry Beardsley, and Ethel Beardsley; (second row) Joe Chalfont (whose mother owned the Blue and White) Dave VanGelder Jr., Art VanGelder Jr., Irv Beardsley, Art VanGelder Sr., Vick Evon, Nick Emanuele, and Otto Jensen; (back row) Herb Northrup, Paul Nolan, Len Walsh, Jim McClouglh, Art Emmons, Ron Vooris, and Ed Gagnon. This photograph was taken at the Rensselaer Recreation, Inc., operated by Howard and Lillian Teal at 6 Second Avenue.

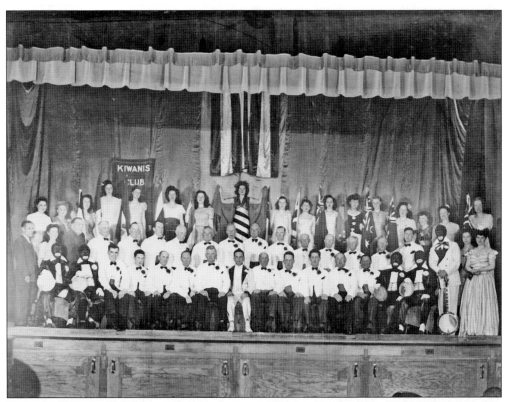

Here, the Kiwanis Club hosts a theatrical presentation.

Mayor Clarence McNally (third from left in second row) appears with students. McNally was the mayor from 1930 to 1931 and again from 1953 to 1964.

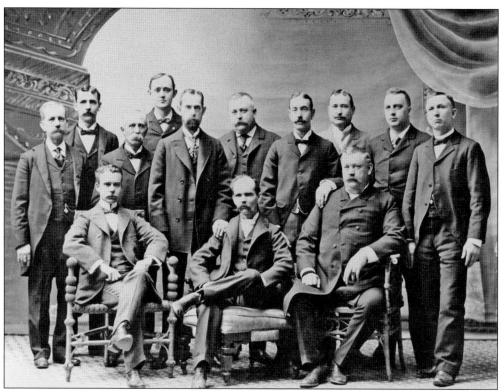

This is a portrait of the First Common Council in 1897. Posed are, from left to right, (first row) Harry Bates, Mayor Bradford R. Lansing, and Cornelius Ryan; (second row) John Parmerton, Frank Bortle, Charles J. Reno, Roswell A. Dandarow, and William Hepinstall; (third row) Thomas Kimber, William H. Cornell, Frank Wilson, and Christopher Short.

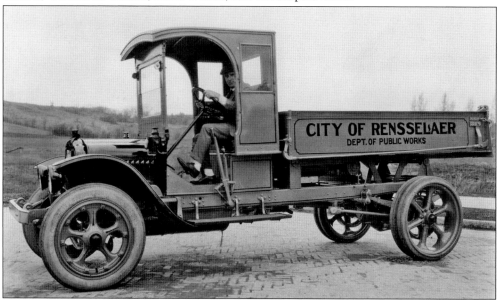

A member of the City of Rensselaer Department of Public Works drives a city truck. The photographer was H.G. Bartlett.

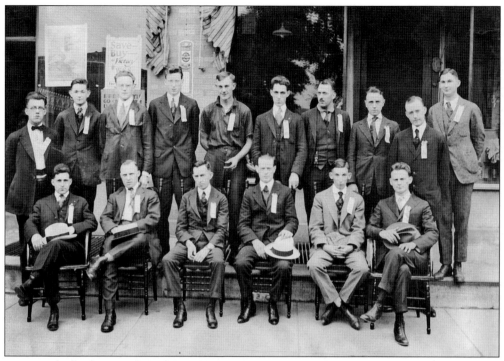

Men pose before being inducted into the Army. They are in front the post office at 240 Broadway. The image is dated July 10, 1918.

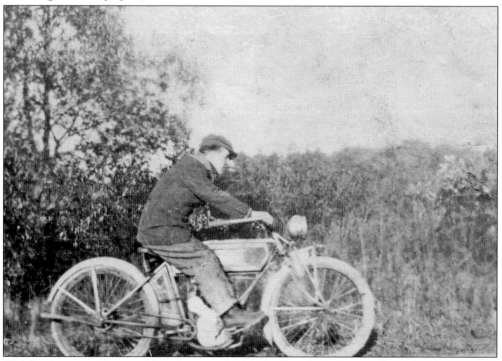

Charles Gavin, at 23 years old, is shown on his Harley-Davidson motorcycle on October 18, 1915. (Courtesy of John N. Gavin.)

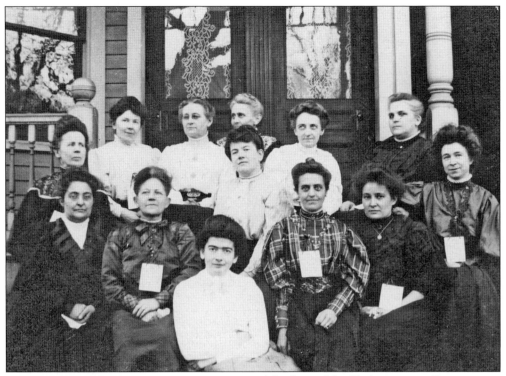

Members of the Shakespearean Society are pictured on an outing around 1910. Founded in 1894, the ladies-only group was limited to 20 voting members but allowed an unlimited number of associate and honorary members. They had meetings with refreshments and discussed many things beside Shakespeare. These subjects included current affairs, geography, history, science, literature, industry, and others. The organization continued until 2000.

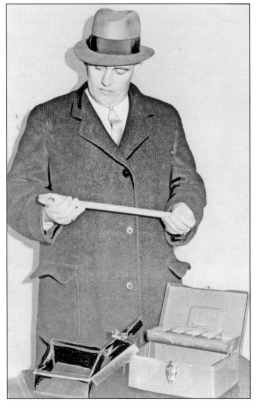

Det. John Warden examines some evidence from a burglary. Detective Warden served as mayor of the city from 1966 to 1971. The public housing complex was named after him.

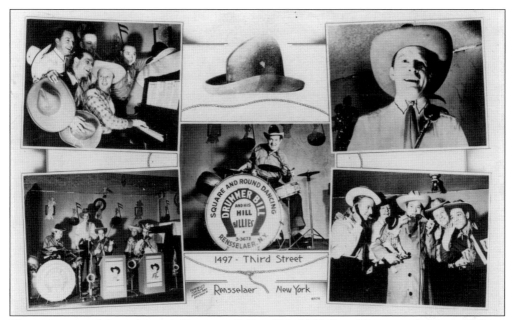

Here is a postcard that advertises Drummer Bill and His Hillbillies. "Drummer Bill" was William R. Distin. He lived at 1497 Third Street in Rensselaer. This photograph dates from 1960–1963. (Courtesy of Joe Connors.)

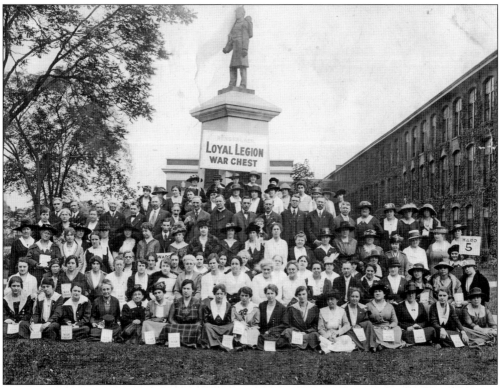

The Royal Legion raised money for World War I efforts. The legionnaires are pictured in front of the Soldiers and Sailors Memorial, which was dedicated in 1910.

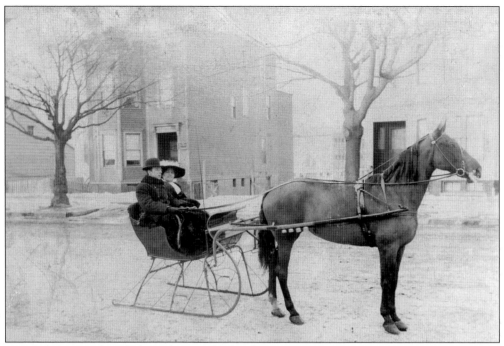

Pictured is an unidentified couple on a sleigh ride on the streets of Rensselaer.

Children in the Grove Street area play during the winter of 1949. (Courtesy William Flanigan Jr.)

Two children pose on the steps of the Goewey house. (Courtesy of Sharon Zankel.)

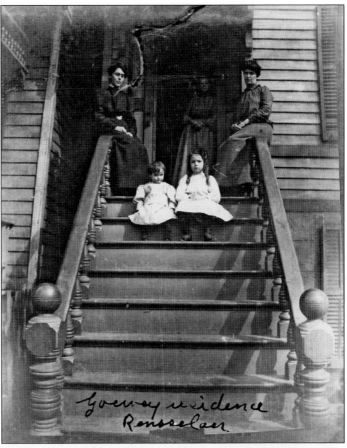

Workmen are shown in Greenbush. It is not known for which company they worked.

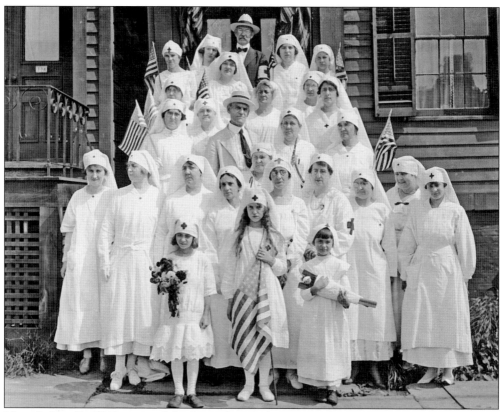

Identified in this 1918 image of the Rensselaer Red Cross are Rev. George E. Stright, Ernestine Hart, Kate Mowers, Mrs. George Meegan, Mrs. William Westfall, Mrs. Herbert Burhans, Mrs. Ralph Parker, Mrs. Edward Bailey, Mrs. George March, Mrs. Jennie Walrath, Mrs. Helen Hackel, and Sara Ryan. Others are not identified in this photograph taken by J.W. Wickens.

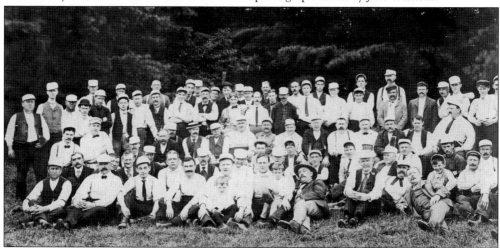

This photograph was taken by Clifford. It shows the T.S. Lasack Association at its fourth annual clambake on August 10, 1902. The chef was J. McIntyre. This event took place at the Dearstyne Miller Inn on Forbes Avenue. Patrons of the Terrence Lasack Saloon formed this group, which had been located at 846 First Street.

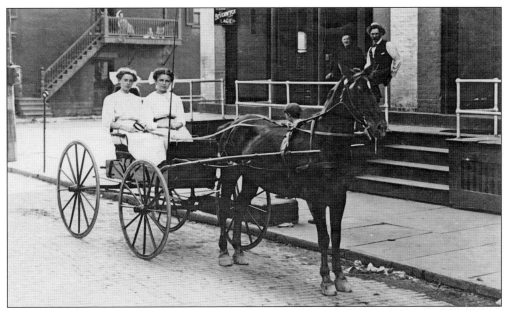

Alice Duff (later Mrs. Lyell Herrick) and Margaret Wicks are shown in a carriage in front of the Rensselaer House hotel, which was located at 203 Broadway and was owned by Alice's father, John Duff. (Courtesy of Ernie Mann.)

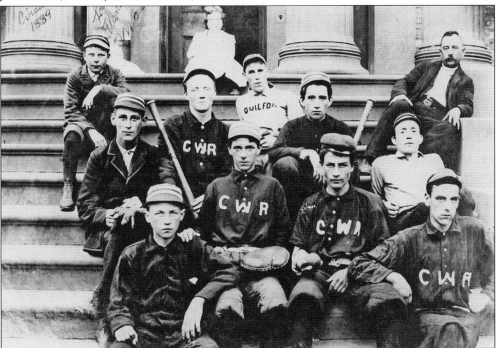

The C.W. Riley baseball team poses in a group photograph around 1892. Lewis J. Flanigan, the mascot, was born in 1883. Christopher W. Riley ran a boot and shoe store in Rensselaer at 842 Broadway. The gentleman with the name Guilfoil on his jersey is quite possibly a member of a team sponsored by the Guilfoil Store on Second Avenue. The location of the photograph is uncertain. (Courtesy of William E. Flanigan Jr.)

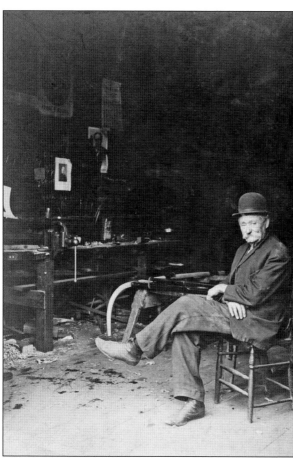

Frank W. Hotaling, a blacksmith, is shown working in his wagon shop, which was located on Washington Street, on July 31, 1916. Hotaling can also be seen in the group photograph of the Ring Fire Company on page 38. (Courtesy of Ernie Mann.)

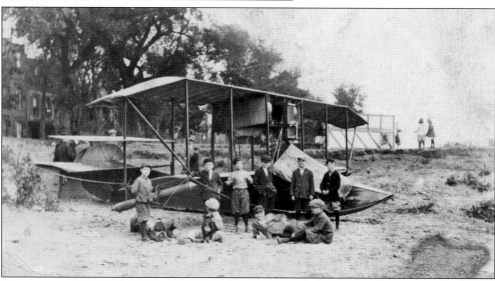

Here is a standard Model E flying boat made by Glenn Curtiss. It has wingtip extensions and antiskid panels on each side of the engine bay. It appears that it is displayed on the shore at Rensselaer. The photograph would have been taken in the period 1912–1913.

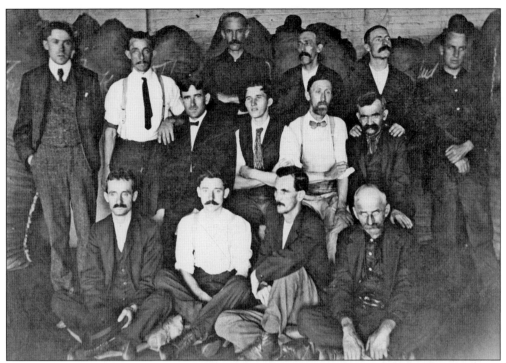

Here is a view of the wool workers at Huyck Mills about 1920. (Courtesy of Ernie Mann.)

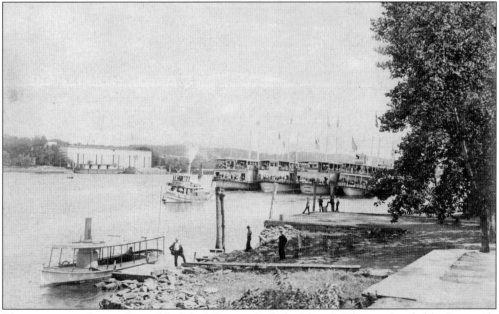

This is an outing by members of St. John's Roman Catholic Church. They are headed for Sunnyside Island near Castleton-on-the-Hudson, south of the city. This photograph was taken in 1900. (Courtesy of Ernie Mann.)

Touring automobiles filled with passengers depart from a location on Broadway about 1915.

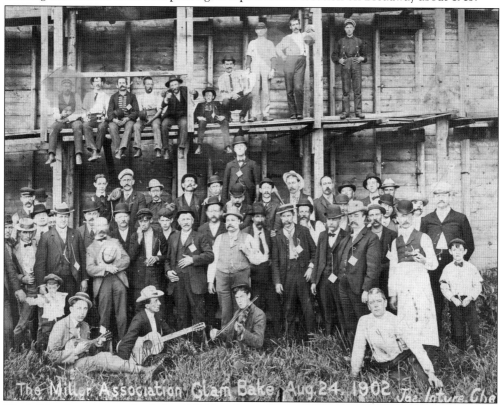

The Miller Association clambake of 1902 is shown here. The Miller Association was formed by the patrons of the Miller Inn (Clark Dearstyne Miller Inn). The location of the clambake was the icehouse on the Hudson. Fifth from the left on the ledge is John Berry. Judge George Stevens is the man with a derby and cigar. Next to the judge on the right is George Berry. (Courtesy of Ernie Mann.)

Bibliography

Anderson, George Baker. *Landmarks of Rensselaer County, New York*. Syracuse: D. Mason and Co., 1897.

Beers, F.W. *County Atlas of Rensselaer, N.Y.* New York: F.W. Beers and Co., 1876.

Gordon, William Reed. *Albany Hudson Fast Line*. Self-published, 1973.

Hayner, Rutherford. *Troy and Rensselaer County: A History*. New York: Lewis Historical Publishing Co., 1925.

Howell, George R. and Jonathan Tenney. *History of the County of Albany, New York from 1609–1886*. New York: W.W. Munsell and Co., 1886.

Mann, Charles C. and Mark L. Plummer. *The Aspirin Wars: Money, Medicine and 100 Years of Rampant Competition*. New York: Alfred A. Knopf, 1991.

Mann, Ernie. *Railroads of Rensselaer*. Charleston, SC: Arcadia Publishing, 2009.

Mann, Ernie and Bill Schilling. *Rensselaer New York, Then and Now: A Pictorial Journey*. Rensselaer: Rensselaer Centennial Committee, 1996.

Murray, Stuart. *America's Song, The Story of "Yankee Doodle."* Bennington, VT: Images from the Past, 1999.

Parker, Joseph. *Looking Back: History of Troy and Rensselaer County, 1925–1980*. Troy, NY: Joseph Parker, 1982.

Reynolds, Cuyler. *Hudson-Mohawk Genealogical and Family Memoirs*. New York: Lewis Historical Publishing Co., 1911.

Sinclair, Douglas L. and Josephine M. Fraser. *Three Villages, One City*. Rensselaer: City of Rensselaer Historical Society, 1992.

Sylvester, Nathaniel B. *History of Rensselaer County, NY*. Philadelphia: Everts and Peck, 1880.

Van Laer, A.J.F., trans. and ed. *Van Rensselaer Bowier Manuscripts*. Albany: New York State Education Department, 1908.

Walton, Perry. *Two Related Industries*. Albany: F.C. Huyck and Sons, 1919.

Weise, A.J. *History of the Seventeen Towns of Rensselaer County, from the colonization of the Manor of Rensselaerwyck to the present time*. Troy, NY: M. Francis and Tucker, 1880.

DISCOVER THOUSANDS OF LOCAL HISTORY BOOKS FEATURING MILLIONS OF VINTAGE IMAGES

Arcadia Publishing, the leading local history publisher in the United States, is committed to making history accessible and meaningful through publishing books that celebrate and preserve the heritage of America's people and places.

Find more books like this at
www.arcadiapublishing.com

Search for your hometown history, your old stomping grounds, and even your favorite sports team.

Consistent with our mission to preserve history on a local level, this book was printed in South Carolina on American-made paper and manufactured entirely in the United States. Products carrying the accredited Forest Stewardship Council (FSC) label are printed on 100 percent FSC-certified paper.

MADE IN THE
USA